Drawing and Painting Animals with Expression

Marjolein Kruijt

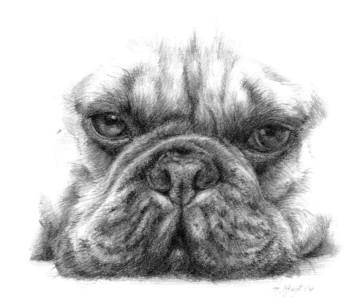

SEARCH PRESS

First published in Great Britain 2017 by
Search Press Limited
Wellwood, North Farm Road,
Tunbridge Wells, Kent TN2 3DR

Copyright © 2017, Edicola Publishing & Marjolein Kruijt.
Originally published in 2013 by Edicola Publishing, The Netherlands.

English Translation by Burravoe Translation Services.

ISBN 978-1-78221-321-5

If you have difficulty in obtaining any of the materials and equipment mentioned
in this book, then please visit the Search Press website for details of suppliers:
www.searchpress.com

Printed in China

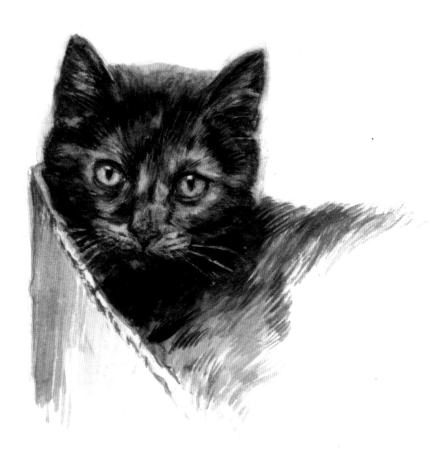

For my dear four-pawed friends, Minou, Yoda, Balou and Oby.
Thanks for your unconditional love and inspiration.
You are forever in my heart.

Ode to the animal

This book is the result of my many encounters with all sorts of animals: from my pets and those of friends, to wild animals I have met on my travels, animals belonging to clients, and animals in zoos. This is a tribute to them, in gratitude for their inspiring beauty. It is a look back at more than thirteen years of my paintings of animals, nature and wildlife. It allows you a glimpse into the world of my inspiration – and it gives those who are interested the opportunity to see first-hand the working methods behind my paintings. Even if it is not your ambition to be a professional artist, this book will offer you inspiration and challenge you to try out new topics or materials. I hope that those of you who do not yet know how to paint learn to appreciate animal art in a new light.

The second part of the book includes demonstrations in pastels, oils and watercolours. I have only briefly explained the fundamental principles of simplifying your subject into basic forms, as I assume that the reader can remember those lessons from childhood colouring books. It is impossible to fit every bit of knowledge on the subject into one book, but it will serve as a good basis for learning how to draw and will contribute to developing skills in 'seeing'.

With my teacher's hat on, I say that the starting point is the talent within each of us – and what is inside, must come out. I hope to encourage everyone, in their different and unique ways, to release it. Imposing fixed methods, ideas and techniques can suppress true talent. Learning to master the techniques is a starting point from which your own inspiration can begin to develop. If this book helps you to listen to your own inner artistic voice, and follow your own intuition and inspiration (with some supportive tips and techniques from me), then my mission will be complete.

At whatever level of painting skill you find yourself, this book is intended as a journey of discovery into drawing and painting techniques and into the animal world, particularly the animals that are dear to you!

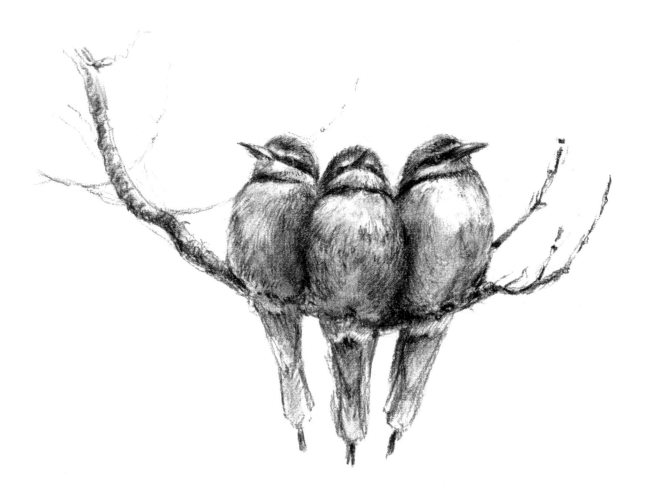

Contents

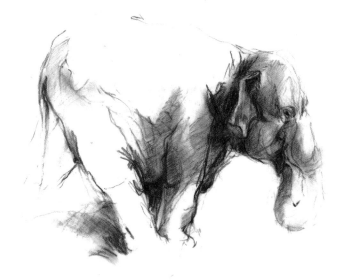

Inspir

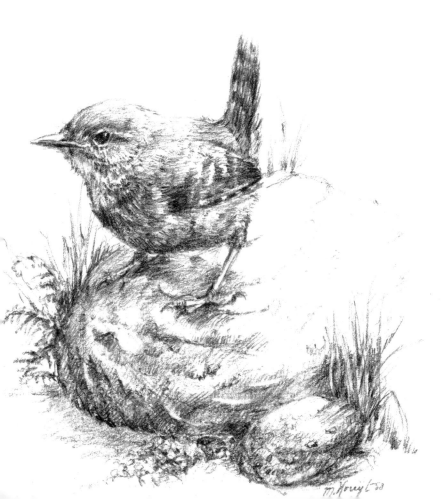

ation

During her many trips across the world, Marjolein Kruijt has explored the great breadth of nature and of animals. She regularly travels to Dartmoor in England, where the old trees, waterfalls, stone circles and wildlife-watching inspire and excite her. On her canvas, she adds a touch of humour and pathos by creating encounters between animals, like ducklings encountering a particular insect for the first time, or the comic 'hairstyle' of a marabou stork. Marjolein sees animals in all their honesty and innocence. They live fully in the present moment. They simply accept what they are and where they are, and they do not have a care for what tomorrow may bring. Using her talent, she wants to make this purity visible to others, making them aware of the fact that we need to take good care of both nature and our animals. As Marjolein explains, we do not always realise what they mean to the world.

The reasons to protect and maintain nature are perhaps obvious, but the healing effect a hug from a pet can have on our health is just as important. They help us remember that we have to live more in the 'now'. A man in harmony with nature will move more harmoniously through the world.

About the artist

Marjolein Kruijt is a versatile painter, but is best-known for her charming portraits of animals, whose eyes convey great emotion and character. Her wildlife art and landscapes also succeed in striking a deeper chord. Her passion for nature and animals has been a recurring theme through her life and, for as long as Marjolein can remember, her art has gone hand-in-hand with animal welfare. When she was young, she took care of the animals that were in her neighbourhood. On roller skates, she went and searched in holes on building sites to find stranded frogs, which she then freed, and she would take injured birds to the vet during the school break. It became clear in primary school that this love for animals also had to be expressed creatively, for her friends all asked her to make drawings of their animals.

In 1997, Marjolein studied to become a teacher of art in Amsterdam, continuing her studies at the Royal Academy of Art in The Hague. She received her diploma in 1999. Her teacher training graduate collection consisted of a series of paintings on the 'Carnival of the Animals', in which animals and music came together. In her lithographs (stone printing) from the Academy, she combined Celtic symbols with expressive landscapes, and sometimes symbolically with animals. She now works full time in her studio, where, in addition to her free work, murals and wall paintings, she undertakes many commissioned paintings of pets. For more than twelve years, Marjolein has written instructive articles for art magazines, where her knowledge of various media, including pastel, watercolour, oil painting and drawing techniques, shines through.

During her studies, Marjolein could often be found in the zoo, where she received her first animal portrait commissions by passers-by who wanted her to immortalise their four-legged friends. Since then, the portraits have become a component of her full-time artistic practice. In 2003, she was featured on television. She also auctioned a painting of cats, signed by the Dutch cast of the musical *Cats*, the proceeds of which went to animal welfare projects. She has also taken part in many successful media projects and has even received a commission from the Sultan of Oman. Her work can be found in collections across the world, including in Belgium, Germany, the Netherlands, Sweden, England, France, the United States and Australia.

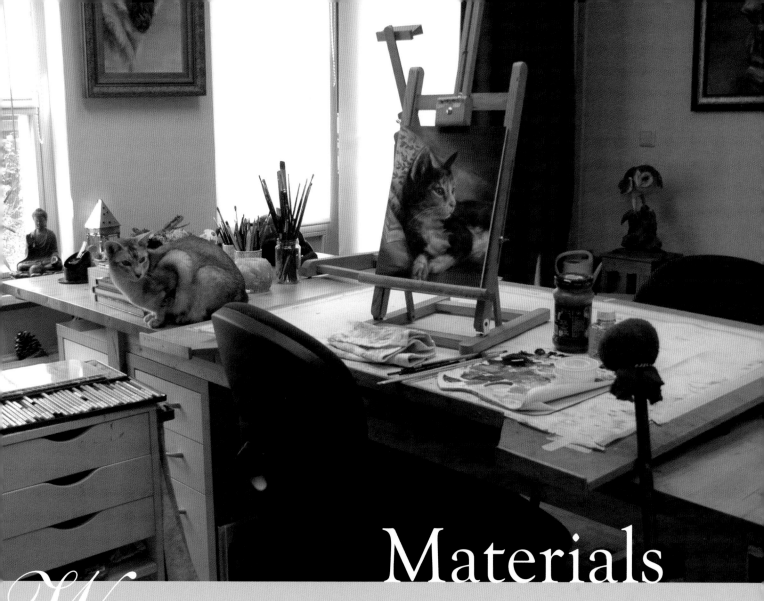

Materials

What materials do you need for drawing and painting animals? In this chapter I give a brief overview of the tools and materials used for drawing and painting with oils, watercolours, and pastel. This is not to say these are the materials you should choose or that they are equally suitable for everyone. For example, if you like coarse paper, then use it – simply use more opaque paint than I describe here. Gradually, as your creativity grows, you will choose other materials. Start off simply, with a limited selection of colours, so you can train yourself in mixing them. I recommend trying out combinations of different materials so that you can create textures and unexpected effects. Go and set yourself completely free with wax crayons, markers, old ink pens, ball-point pens, or other materials that have long been hiding at the back of the cupboard. Try pouring water over pen drawings, or even spill a frightening amount loosely over your work. Make painting animals playful so that you enjoy it and experience a voyage of discovery, rather than a struggle to overcome technical difficulties. By moving your boundaries, you create the ability to learn through discovery. This sort of victory gives you such a boost of energy and inspiration.

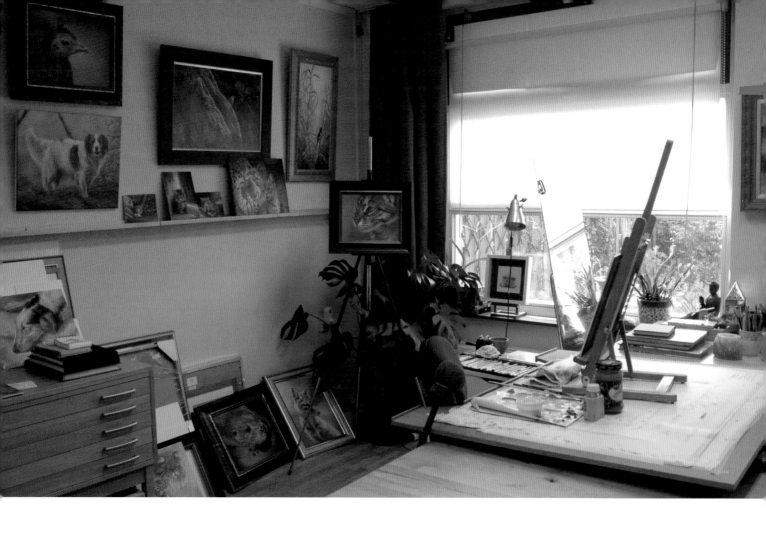

Workshop equipment

A workshop should be an inspiring place. That is why, in addition to a practical layout, I have all sorts of items that I find inspirational surrounding me: stones, feathers, branches, animal skulls, pieces of moss and other natural materials that I have collected form a kind of 'nature cabinet' in which I can always find something to use as an example while painting. They also remind me of happy holidays, which evokes further inspiration. I have a long, large table that I can slide out. It has a large flat panel with hinges at the rear which allows me to work in any format. In addition, I have an easel in another corner and some smaller table easels. Depending on the material I use, I work in the appropriate corner of the workshop.

I keep my workshop very organised, so I can always find everything. For example, in my cabinet, there is a drawer for each medium. My watercolour board and paper are in one drawer while my pastel paper and drawing pads are in another. I store drawings in acid-free artist boxes and folders. A mobile hairdressing trolley serves as a side table for my palette and oil tubes. I store my pastels in pastel boxes and an old coloured-pencil box. Even my brushes are arranged: I use different pots for old and new hog bristle brushes, as well as brushes of various different bristle types, all sorted by thickness. This way, everything is to hand.

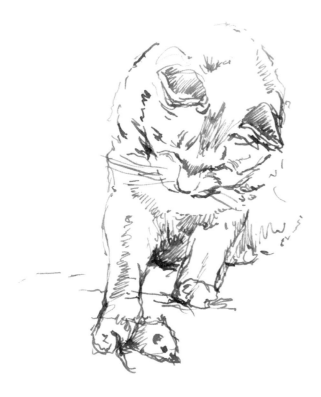

Lighting is very important. If your light is too blue, or too yellow, it can result in you making the wrong colour choices. I prefer to work in daylight, but I also want bright light in the evening. On the ceiling I have four fluorescent lights suspended with two tubes inside: one daylight (blue) tube and one normal tube (which is somewhat more yellow). If I mix these two together, I end up with a really nice working light.

I am right-handed, so if I work during normal daylight hours, then I position my table or easel so that the light from the left falls without creating any disturbing shadows. Furthermore, I also hang paintings that I have done on the wall to create an ambience.

Note: Pastels, oil paints and watercolours are explained in more detail because they play a more important role in this book.

Charcoal and pencils

Charcoal is nothing more than charred wood. It is available in loose sticks in various thicknesses, and as conté sticks, which are also charcoal, but with a fatty binding agent that makes the lines drawn blacker and helps them to adhere to the paper. For sophisticated drawings, I often use the thinnest piece of charcoal I have, and use the edges of the stick to draw sharp lines. In the zoo, I work with thicker charcoal, so that I can quickly apply areas of shade.

Charcoal pencils, in various degrees of hardness, are also available. These can be resharpened using a pencil sharpener or a Stanley knife. I also use pencils in different grades from 9H (hard) going down to 9B (soft), either in cased pencil form or as pure sticks of graphite.

In addition to being used for correcting work, a kneadable putty eraser can also be used as a good tool – for picking out whiskers from a grey area, for example.

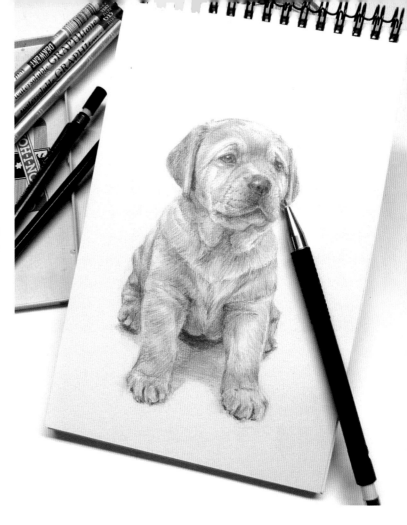

Choose smooth HP (hot-pressed) drawing paper for detailed drawings and Not surface (short for 'not hot-pressed') or rough surface watercolour paper for added texture. Protect finished charcoal and pencil drawings with fixative spray or liquid fixative applied with a spray diffuser. Do not use hair spray: this can lead to discolouration.

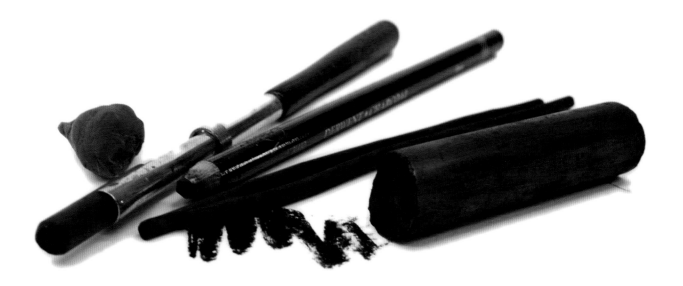

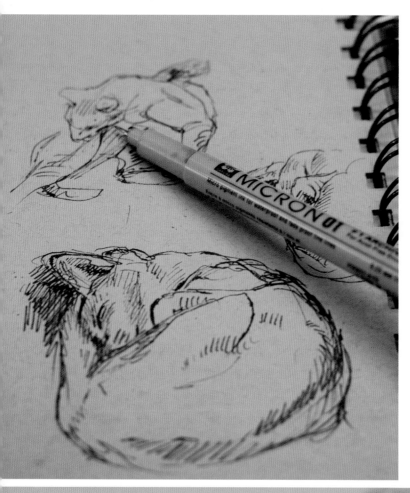

Inks

Creating detailed ink drawings depends upon using water-resistant ink pens. I often use the 0.3mm, 0.5mm and 0.7mm fineliner pens. Drawing on smooth drawing paper is perfect for details.

The line width of a dip pen varies due to the unequal distribution of ink, which is something that appeals to me. You can also use a watercolour wash or diluted ink over ink drawings, a technique seen in drawings by the artist Rembrandt. When I'm travelling, I use sepia and black in my sketch books. I also regularly use my old fountain pen in my studio, along with a pot of Indian ink. Indian ink is waterproof, so it does not need to be fixed.

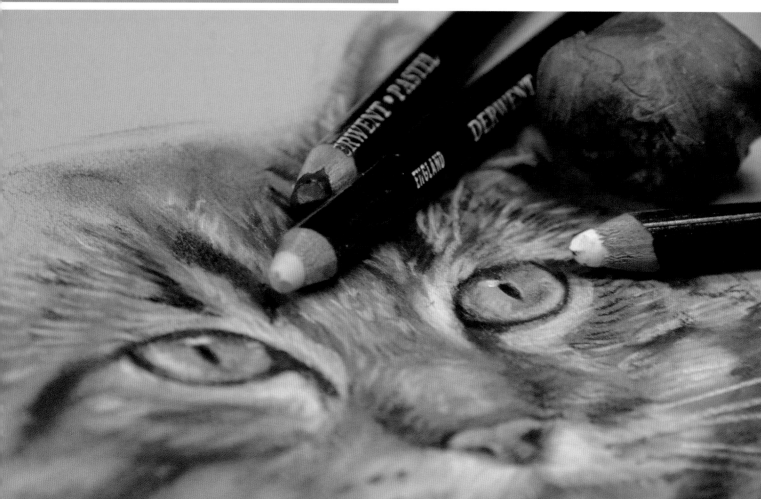

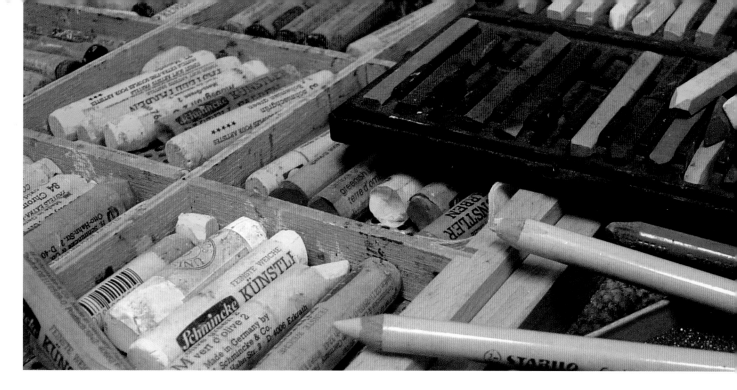

Pastels

Pastel is simply pigment powder combined with a little binding agent, and is available in different forms – round and square sticks, as pencils – and also in different hardnesses. Just like any other material, the quality of the pigment determines the colour fastness and colour intensity. It is worth investing in a good basic set of colour-fast, artists' quality pastels. The hardness and colour intensity vary by brand, so over the years I have put together a mixed collection. Pastels made by Derwent, are, for example, softer than Stabilo ones, which in turn give you more intense colours. For coats, I use pastel pencils, and for underlying coloured areas and backgrounds I use pastel chalk.

Surfaces

Powdery pastel needs paper or board with texture or 'tooth', so that you can work in multiple layers. There are several types of textured paper available. I use a lot of Colourfix paper from Art Spectrum, which is available as ready-to-use sheets or as a primer in different colours. The great advantage of Colourfix is that the top layer is waterproof, so that you can combine your pastel work with acrylics or watercolour.

Although textured paper is the sort of surface I use most regularly, other textured surfaces such as Ampersand Pastelbord, pastel artist panels and pastel card can also be used.

A basic colour palette for animals

Pastels:
- any brown and grey tones
- ochre
- dark blue
- ultramarine light blue
- dark purple
- light and dark pink
- dark red
- grass green for the eyes
- light and dark yellow
- black and white (also in chalk form)

It is easy to apply pastel primer with a roller to acid-free mount board or panel. This allows you to work on a large format without ending up with an undulating background. The colour of the paper can be used a base tone for the drawing. For example, you might draw darker animals on darker coloured paper. It is therefore useful to build up a stock of different colours of paper.

Other available pastel papers include Canson Mi-Teintes, velour paper from Hahnemuhle, Ingres paper and Schmincke's Sansfix paper (which has a sandpaper-like surface). Working on velour paper requires both patience and precision. The results are very soft and almost photographic in style. To make things as clear as possible, I name the paper types used in various works throughout the whole book, in order to differentiate them.

Fixative

If your paper becomes saturated with pastel while working and the colours start to merge together, then you can use a fixative. Fixative is available in spray cans, with and without a UV filter. However, be careful, because by using fixative, the colours may lose their brightness and clarity. Test the paper in advance to see how the fixative may change your pastel drawing.

With pastel paper that has more tooth, a fixative is not always necessary provided that you fasten the paper securely within a frame using a mount.

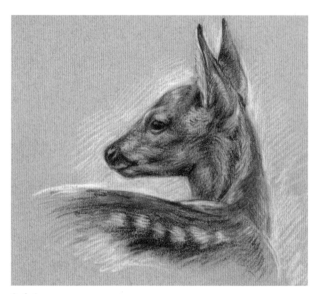

Safety

Inhaling pastel substances can be very harmful. The use of a face mask, frequent vacuuming and washing your hands between sessions is important. There are also creams available in art shops that will apply a thin protective layer to your hands so that paint and pigments are not absorbed through the skin.

Top to bottom:
Mi-Teintes, Sansfix, Colourfix

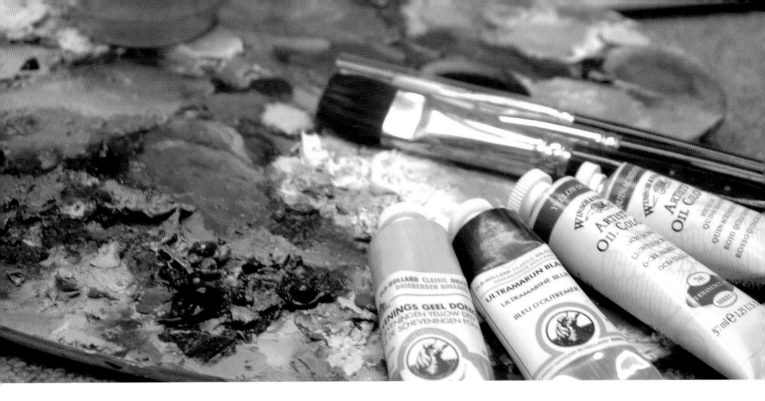

Oils

My advice is to always work with artists' quality materials. This will help prevent any disappointments in the future – such as your work fading – as well as avoid you having to learn how to deal with the materials again. Artists' quality paints have a higher content of natural pigments than students' quality, and they do not contain chemical pigments, which can mean you get a slightly different hue when mixing colours.

I work with Winsor & Newton, Old Holland, Rembrandt and Holbein paints. I also use the non-toxic Gamblin paints, and spirits. Just like with pastels, over the years I have a developed a preference for using a particular manufacturer for a certain colour. I use a tear-off palette with a white background.

The level of transparency can vary between colours, which can be seen on the paint strip on the tubes.

Colour palette for animals

Oils:
- raw and burnt umber
- Vandyke brown
- burnt sienna
- yellow ochre
- titanium white
- ultramarine dark blue
- cerulean blue
- cadmium red
- quinacridone red
- cadmium yellow, dark and medium

I rarely use black, but instead a mixture of ultramarine, burnt umber and quinacridone red.

Surfaces

Oil paint can be applied to a linen or cotton cloth tensioned over stretcher bars, MDF or Masonite panels prepared with gesso, pre-processed panels, or oil paper. If you are able to tension cloth yourself, then there is the advantage of being able to find a better quality linen and using unusual sizes.

I work on fine-textured portrait linen (such as Belgium linen), ordinary linen cloths and home-prepared Masonite panels. Masonite can be ordered from good timber traders. After cleaning panels to remove any grease, I prepare the panel by applying multiple coats of diluted gesso with a roller, lightly sanding it between each layer. When I lack time to prime panels myself, I buy pre-primed art panels, like Ampersand gesso board.

Tip

I have two jam jars full of leftover odourless turpentine to clean brushes with. I let the pots settle there after use and alternate between them every day. The top layer of turpentine is then clean again and is simply poured off for its next use. This is how I have used the same bottle of turpentine for years, with very little chemical waste.

Mediums

I add different mediums to my oils to alter its qualities depending on the effect I want. For example, I will add a little quick-drying medium if I want to work in a single layer. Adding purified linseed oil results in a thicker paint that dries more slowly, which is ideal for applying a number of transparent layers one on top of the other. This is also good when you are painting fur, because you can soften the colour transitions for longer. Liquin Fine Detail is great for details and glazing.

Brushes

It is possible to buy brushes that have harder or softer bristles. Hog hair brushes are much stiffer than smoother synthetic, ox hair and sable hair brushes. The choice depends on the result you want to achieve. I use old hog brushes for coat structures (see the 'rabbit' demonstration section at the back of the book) and synthetic round brushes for specific details, such as whiskers. Flat brushes and fan brushes are ideal for softening colour transitions in coats and fur.

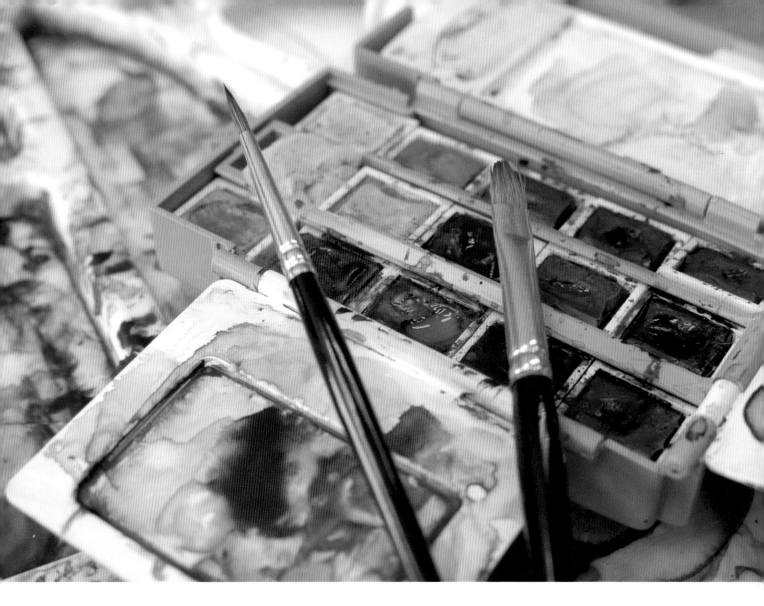

Watercolours

This paint is available in tubes or in pans. By adding water, it becomes fluid. Good quality pigments, acid-free paper and UV varnish mean that, nowadays, watercolours can last for a long time. I prefer to work with tubes, because the paint is liquid and all the colours are more intense.

You should take note to choose fade-resistant colours – some red pigments are not. Why they are sold remains a mystery to me. The light-fastness is generally marked on the label with plus signs; the more plus signs, the less it will fade.

I also use tissues to blot off excess water and paint from the painting. Watercolour boxes with cups are useful when travelling.

Colour palette for animals
The colour palette I use for watercolours is identical to that for oil colours (see page 17). This is because, originally, no white was used with watercolours – the light areas were avoided when painting. Watercolour is transparent, in contrast to gouache, an opaque 'watercolour', where white is used. I use black sparingly, and only with a touch of red or brown.

Surfaces

Absorbency varies by paper type and with it the possibility of making corrections. You should therefore carry out different kinds of tests to determine which you prefer. There are types that have lots of surface texture and those that have very little. It also comes in different thicknesses. I often use 200–300gsm (90–140lb) paper, which does not need to be stretched. Watercolour board and watercolour blocks are useful when travelling.

> **Tip**
> Never use black as an additive colour to darken other watercolours, as it creates a dirty sheen. Instead, get deeper brown tones by mixing brown with other deep tones, such as indigo blue.

Masking fluid

This is a rubber-like liquid that you can use to section off the elements that you want to keep white in your painting. Once dry, the rubber repels the paint, which means that, once removed, the paper remains a brilliant white. This is useful for marking out whiskers. It requires some finishing work, so that the hard dry edges of the paint around it are softened with a clean wet brush. Do not allow masking fluids to sit there for weeks, as this can damage the paper. Blue masking fluids can even discolour the paper, turning it blue.

Brushes

When it comes to watercolours, the choice of brush is very important. Sable and squirrel hair brushes hold lots of water, which makes painting with them much easier and more comfortable. As an animal lover, I prefer to use synthetic brushes as much as possible, which I find work just as well. I use wide flat brushes for backgrounds and glazing, and round, smaller brushes for details, fur and hair.

On location

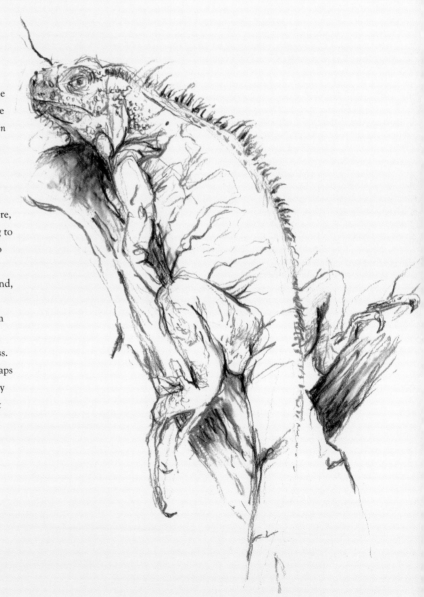

Carrying a heavy folding easel, we set out enthusiastically over the English moors, looking for a uniquely intimate spot where nature and light would inspire me to create unprecedented works *en plein air*. Unfortunately, all the animals must have heard me coming, because after hours of trudging around, carting my easel around like a packhorse, I was left with the pain in my back as my only source of inspiration.

Eventually, I ended up sitting in the blazing hot sun, with a sore, hunched back and a full bladder, dodging the mosquitoes, trying to breathe life back into what I thought would be my first foray into the romantic. The sun seemed to tease me by quickly changing position and, as one of my colleague's easels flopped to the ground, wet canvas face down, I burst out laughing. It was ridiculous!

I'm sure I am not the only artist to head out full of enthusiasm on a fruitless day trip like this. The conclusion is simple: there is nothing inherently romantic in painting outside in the wilderness. This is hard work that requires speed and experience – and perhaps carrying less and drinking less. In the wild, animals unfortunately do not pose for long, so we have to rely on other locations, but it still remains a challenge that requires perseverance.

Where can you draw animals?

There are many places in which you are able to draw animals. Not only in the zoo, but also at your local riding stables, the pet store, a farm, by the sea or in the park. In a nature museum, you can also work from stuffed animals. When you begin, you can start in a relaxed fashion by drawing your pets, or those of friends. With a little more confidence and with your headphones on, if you prefer to distance yourself from your environment, you can then head out of the door.

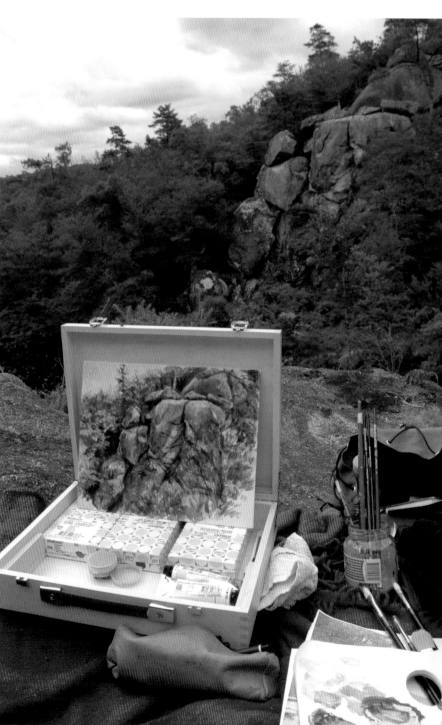

Tip
Keep reference of the animals that you draw for comparison. If you view animals in different places, you can customise any abnormalities in your work. In the zoo, for example, birds have their wings clipped, bears are sometimes too fat, others have the wrong fur or plumage in relation to the season, and the name plates are not always correct. In a museum, animals are sometimes badly presented or discoloured.

I collect bones while travelling and on walks. Complete skeletons can be found in natural history museums. For stones, moss, leaves, branches, shells, feathers, and similar details and textures, I have my own reference material to hand.

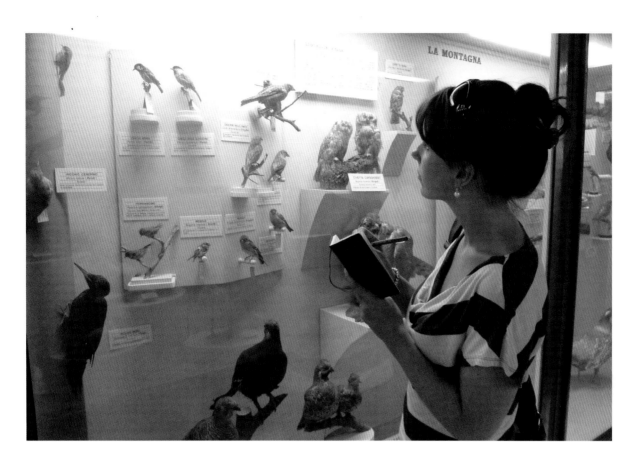

Why work from observation?

I often get asked how you can capture the liveliness of animals and nature on canvas. To achieve this, you have to start with your subject, the anatomy, skeletal structure and how the muscles work, so that you can create the impression that the animal could move about freely at any time. In addition, it also depends on your skill, or whether you can translate what you are seeing onto the paper.

By drawing from observation, you are using all of your senses. You can walk around your subject, you can touch it and smell it. Outside, animals' coats seem so much richer in colour and you can clearly see the muscles as the animal moves. The more you draw from observation, the better you will learn to look, even though many sketches will undoubtedly fail. You will find, if you keep sketching, that it becomes simpler, that it becomes easier to omit details and that you can capture the essence with rapid, direct outlines. It makes you feel great if you can create a number of good matches.

Practising will also make it easier to change the position of an animal in the painting, as well as the light and the colours, at your discretion. Then, you will no longer be dependent on photographs. You will learn to see that an animal in a photograph is flattened, and that rendering it on canvas takes more energy than painting an object that is stood before you. If you know your topic both from the inside and the outside, then you can eventually draw it from memory from any angle.

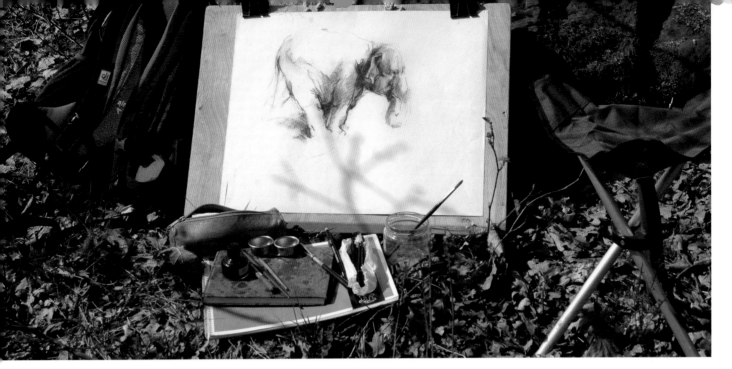

Which materials?

Do not take your whole studio with you, as you will only use half of it. Half the battle is working your painting out in your mind beforehand. Choose one or two techniques and get your materials ready the day before you head out. Take a folding stool and two sizes of paper in a cardboard portfolio that you can also use on your lap as a support. I use thick drawing paper with a light texture that holds the charcoal better. Soft cream or tinted paper is perfect for pastels or charcoal/conté.

You may also need a sketch book, sketching materials like charcoal or pencil, a putty eraser, tape or clamps for your paper, a cloth for your hands, binoculars to see details, a camera, a water bottle and lunch, sunglasses, an umbrella – and your inspiration. For outdoor painting in the open air, I no longer take a big easel with me on my walks, but my painting box that I can put on my lap (there is a picture of this on page 22). I also have a small foldable blanket that I always take with me to sit on. One side of it is fabric, the other plastic, which means I can stay dry even when sitting for long periods in the woods. If possible, place all your materials in a compact, sturdy backpack.

I do any fixing at home so that I don't damage nature (or make the animals cough!).

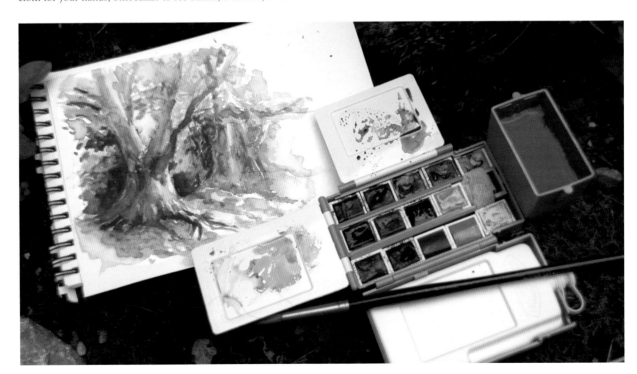

Basic drawing techniques

Once on location, I take a little time to walk around and get to know the area. This makes it more relaxing. As soon as I sit down on the stool with the portfolio, I take some time to observe the animal. How does it move and how does it behave? What state of mind does it look like it is in? I then throw myself into drawing. As soon as I see some movement that inspires me, I get started.

The following pages explain four drawing methods that will help beginners. Try them and see which one you like. Some people draw better if they concentrate on compositional areas and others using shapes and contours.

1. Drawing using compositional areas

If you want to work from the basis of compositional areas, then look at the animal as a whole and draw only the shadows. This is a quick way of drawing, ideal when you are at the zoo. To begin, sketch the shape of the head, then the background and the position in outline form. Everything is initially set up in compositional areas. After that, it is possible to add more details. The elephant below was drawn with a flat conté crayon.

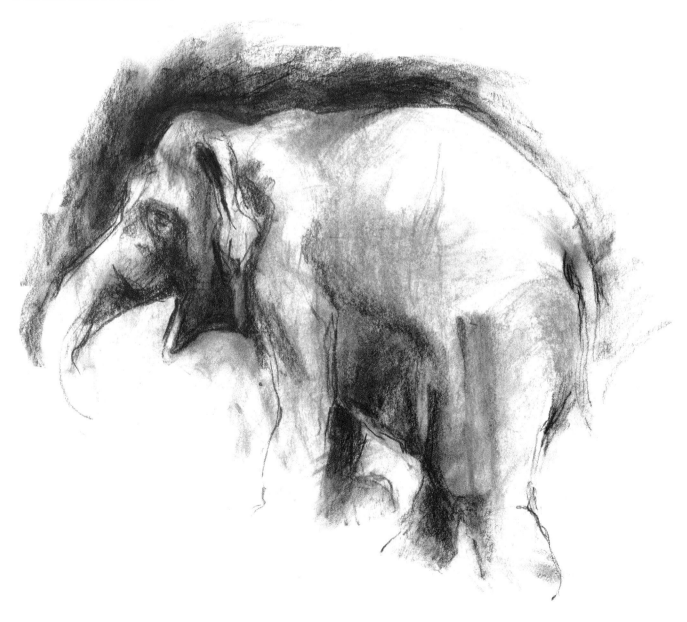

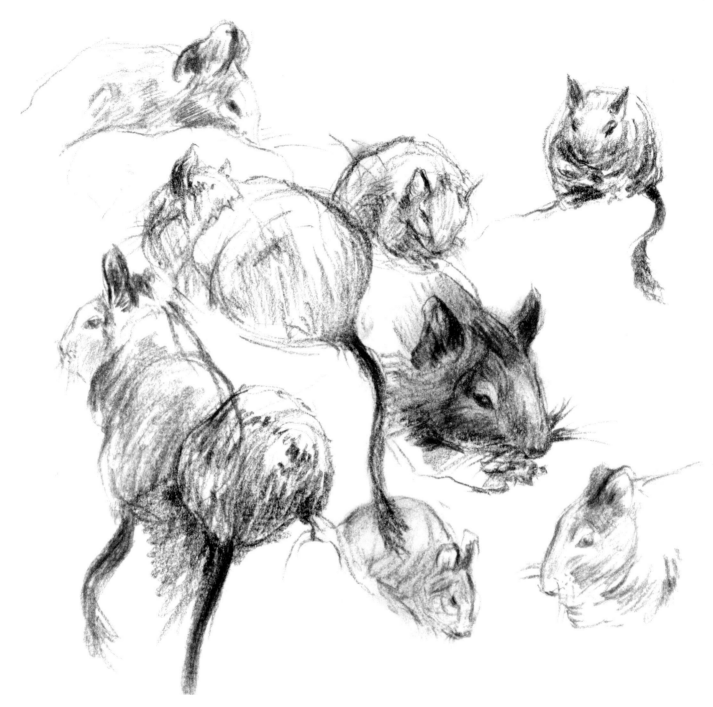

2. Linear drawing (with lines)

Starting from one point, I begin to draw using a few guidelines to ensure the correct proportions. Because animals do not always sit still, I work on a number of drawings simultaneously, as with the mice shown here. As soon as one of them adopts the right position again, I continue with that particular drawing. This creates a nice set of sketches. The iguana on page 21 remained still for longer, so after sketching the outlines and the limbs, I still had time to work on the dorsal crest and the skin on its head – first the outline, then the details.

3. Mixed media

I first sketched this Congo peafowl using charcoal. He did not remain still even for a second, so I filled up several pages with sketches before I created this one. This meant that, in the mean time, I had become familiar with the form. Using a flat piece of chalk, I made the breast and head darker, then used a kneaded eraser to create the feathers, before refining them with charcoal pencil. This way of drawing lends itself to more details, because you start with the master form as a base. Once the form and contrast are on the paper in shades of grey, you can enjoy creating details such as the feathers and the crazy hairstyle on this bird.

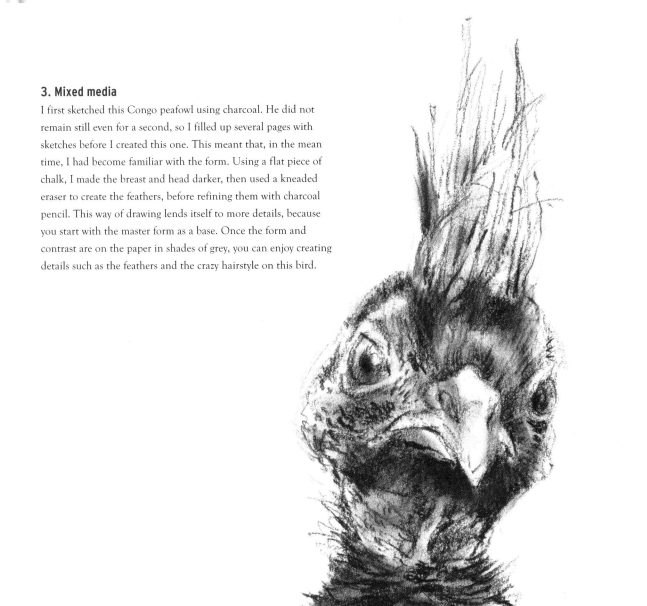

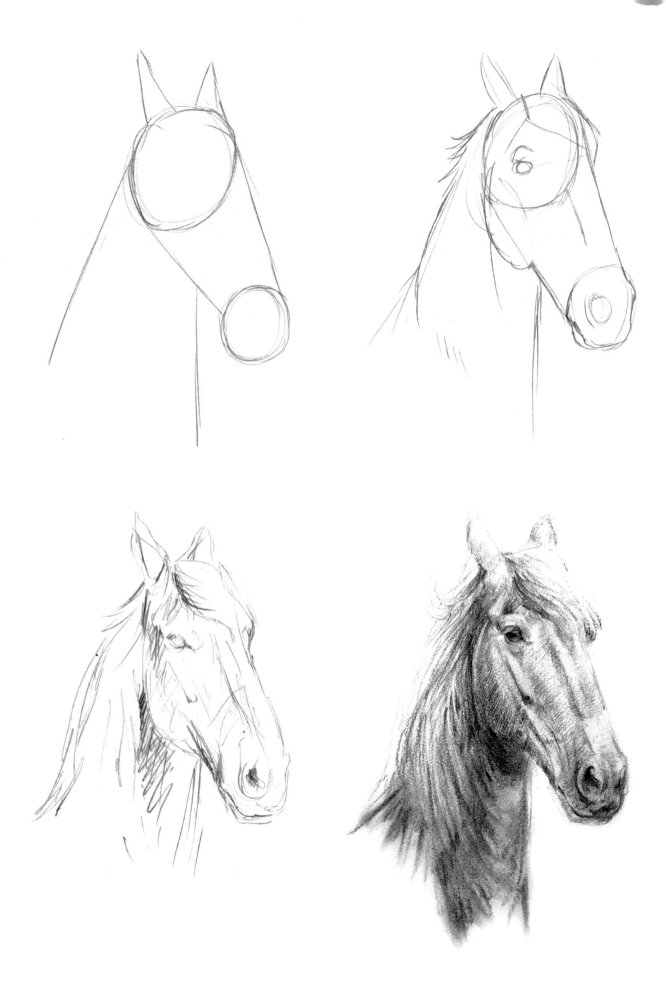

4. Drawing from basic shapes

I particularly recommend this approach for complete beginners. It is ideal as you do not get lost in the details, but instead learn to see an animal as simple basic shapes. These might be circles, rectangles, ellipses, and so on. You then smooth out the contours, after which you add in the shadows in the direction of the coat.

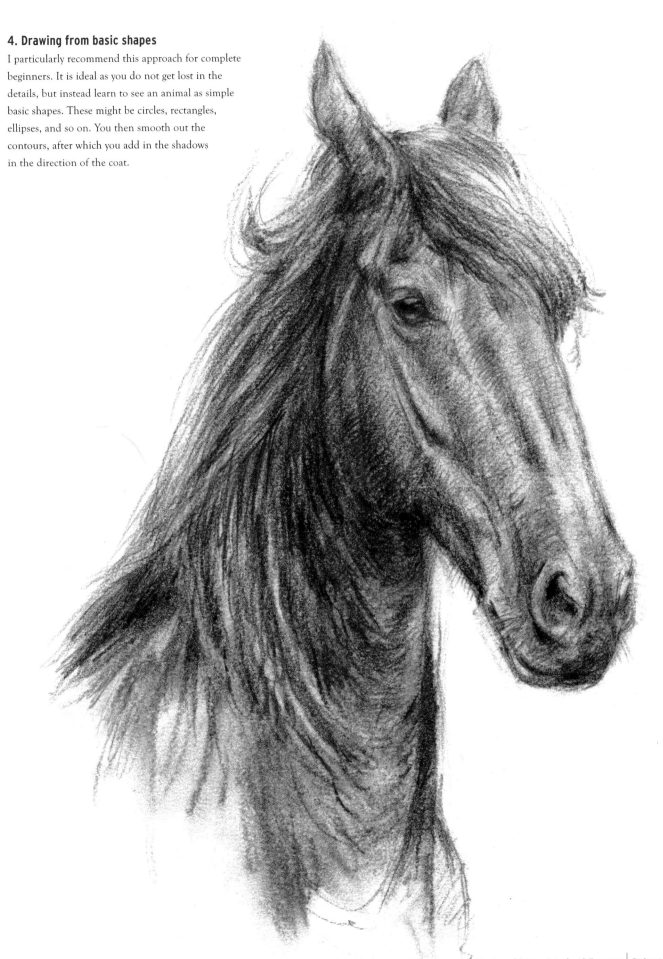

Stuffed animals

Stuffed animals are especially useful, since you can draw calmly and quietly. You can consider the feathers and fur well and, using a bright lamp, you can experiment to see what lighting from the back or side does to the colours and forms. Unfortunately, there are numerous badly stuffed animals out there, so keep comparing them to real animals (in films or photographs, for instance).

If you choose to place the animal in your painting in an environment, pay attention to details such as whether the animal is in their winter or breeding plumage.

On page 33 you will see an example of a painting that I created with the help of the stuffed Crested Tit below. The colour of the feathers had perished and he was not quite right in terms of shape, so I changed this in the painting. I picked up the branch with moss on it and the pine needles for reference while on a walk. With a lamp positioned on it, I could see what effect the backlight had on the transparency of the moss.

Stuffed animals' feathers and coats are often discoloured.

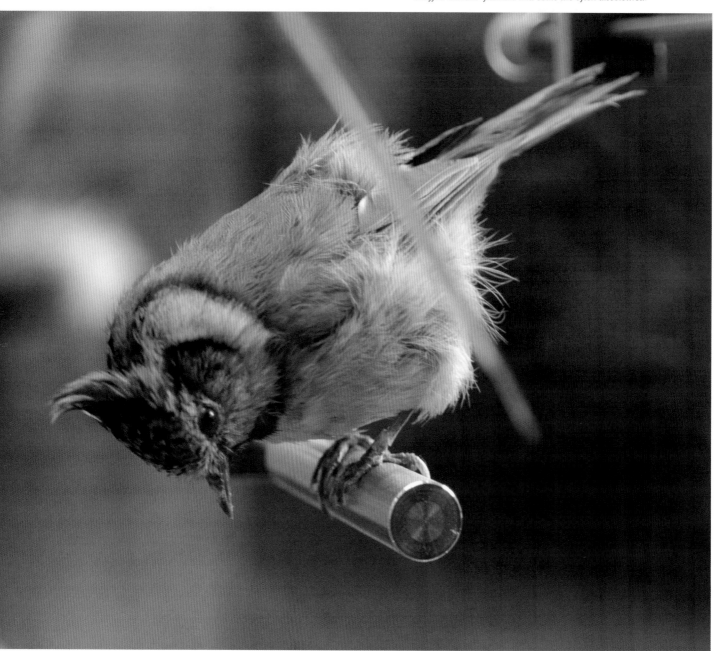

Light

Take a ball and position a bright lamp on it. There is a light side and a dark side. This shadow goes from light to dark. The ball itself also casts a shadow on to the surface (a cast shadow). If we now put two balls next to each other, with two lamps, one on each side, then the shadows overlap together. How many grey tones do you see there?

This concept also applies to animals. Whether you're starting to work from a photograph or from observations, it is important to discover what light does to the basic form. You can therefore simplify this for an animal, to see where light is falling and shadows are created. This makes drawing much simpler. Below you can see an example of the Crested Tit.

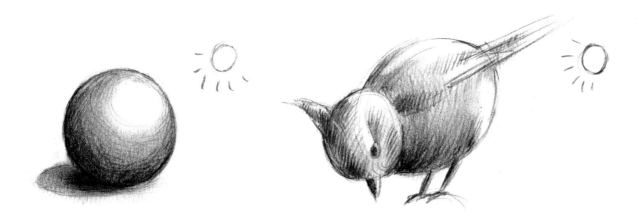

Whether a three-dimensional aspect in your drawing works successfully or not will depend upon whether the shadows have been drawn correctly. In addition, animals also have colouration, a coat, and feathers, with or without a pattern. Before I started painting, I sketched the Crested Tit in various poses, so as to better understand the anatomy, including where the wings were attached and the differences in the feathers.

I also modelled the Crested Tit in clay and, using a backlight, I looked to see where the light fell on it. Once familiar with the subject, I worked up my sketches onto panel.

'Feeding Time' – Crested Tit, 18 x 24cm ›
(7 x 9½in), oil on panel

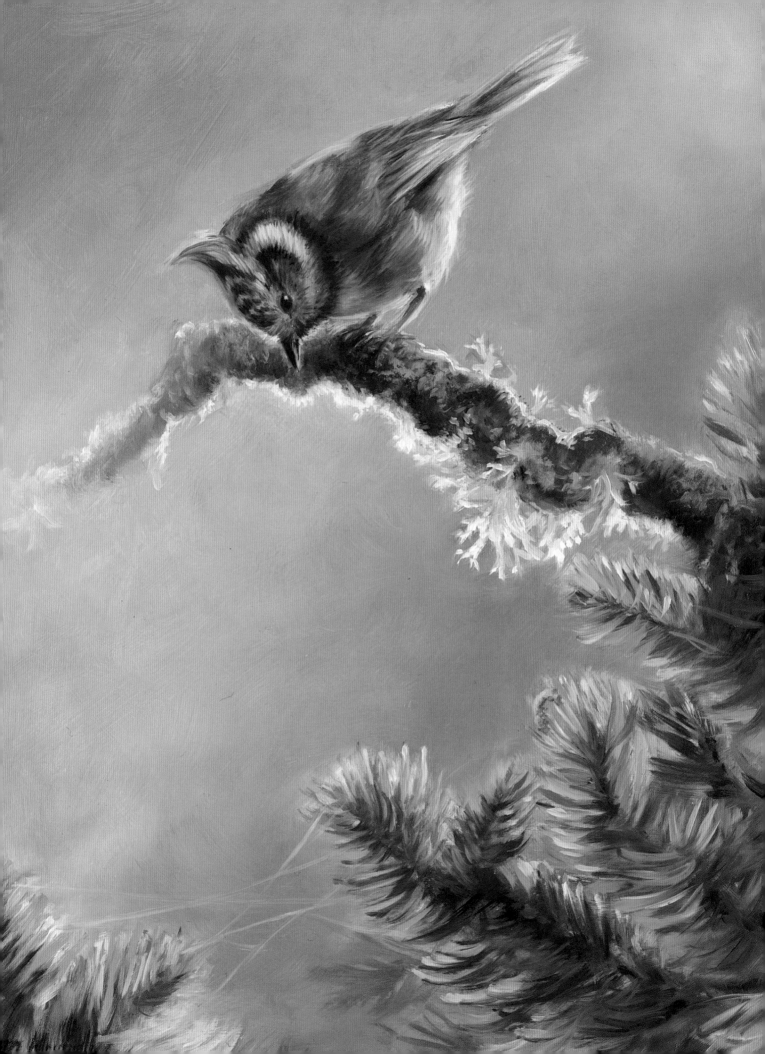

Using photographs as inspiration

Nowadays, many realist painters take a digital camera with them on all their journeys. They use it to take home with them even the tiniest blade of grass, ready for painting. A camera does have its advantages. You can quickly capture a subject and save the photographs for years. But there is also a lot that is lost: the atmosphere, the colours, your direct personal experience, as well as the fact that the depth and light that we see with our eyes is different from that on a photograph. Painting from photographs can also give rise to inadvertent errors, too. For example, you might use a picture of a bear from a past zoo visit, but paint it in a winter landscape – not realising it is in its summer coat.

In any case, why would you have a lovely animal photograph, yet aim to copy it exactly? Your own interpretation and creative conceptualisation protect you in a way from the digital age and stop you being a slave to your own photographs. It can be really satisfying if you are able to add something unique to everything that you create.

For me, my reaction to the environment or to an animal that I have met on my travels is the most important thing. This way, a holiday is no longer just a holiday, for I walk around, soaking up all the impressions around me like a sponge. Often, I only look for my inspiration once I have designed something in sketches, but also the other way round. I see photography purely as a reference point or a study of details like coats and eyes.

'Labrador', 30 x 40cm (11¾ x 15¾in), pastel on Colourfix ›

Here you can see how the coat, which has been over-exaggerated by the flash (below), has been corrected in the finished portrait (right). The flash not only gives it an irritating gloss, but the colour of the eyes has changed as well. Because I have a lot of experience with the anatomy of dogs and black coats, I have replaced the brilliance of the camera flash with a natural sidelight and made the eyes a normal colour again (though note he has two differently-coloured eyes). It can also help if you get another black dog that you know to pose for you with a sidelight, so that you can see what happens to the colour of the coat and which parts of the head have a shine to them.

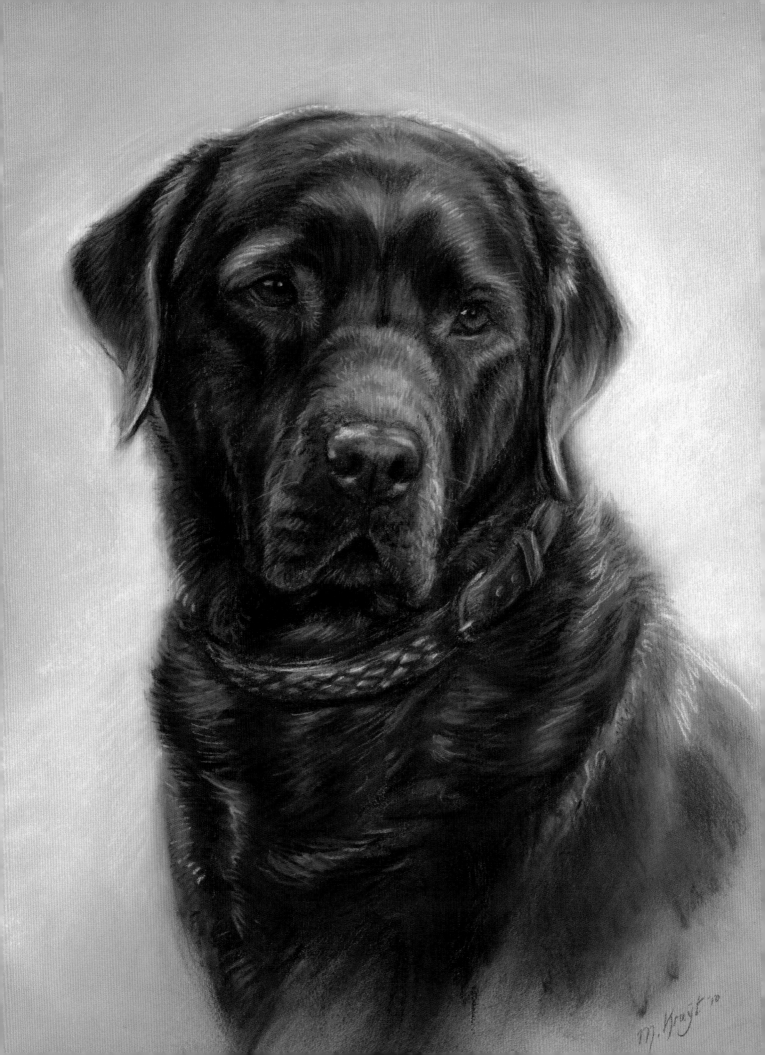

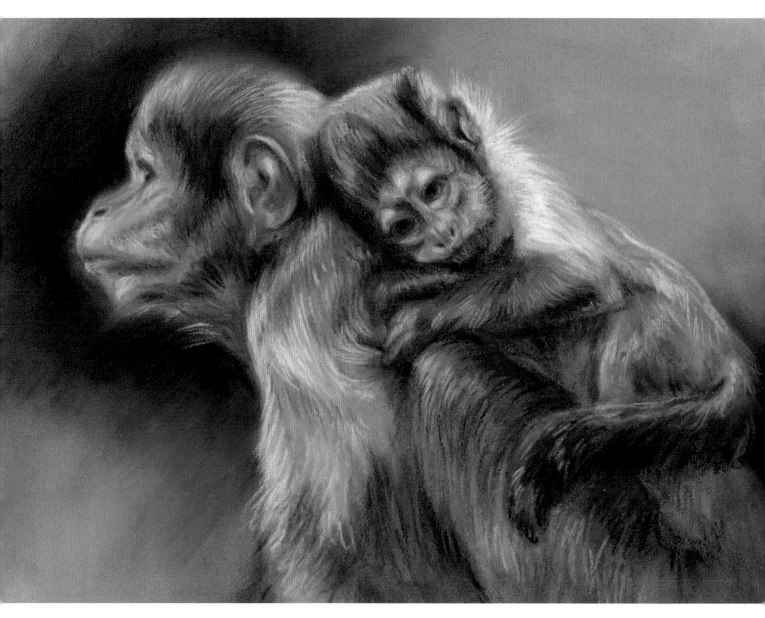

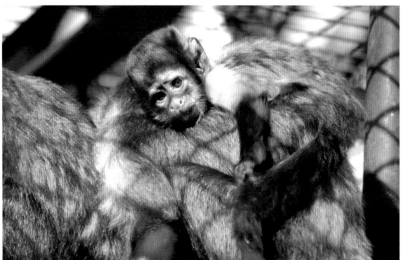

For this little monkey, I used several pastels. In addition to the quick sketches that I made on the spot, I also used this photograph as reference to better express the coat. I wanted to portray the poignancy and dependency of this little one and the mother's watchful alertness over her surroundings. As you can see, I changed the body outline of the little monkey, the mother and the surrounding area as required for the benefit of my inspiration and the atmosphere of the work.

Your own style

The more you sketch, the more you will develop your own signature style – you draw what you observe, and use the colours that you perceive personally for an uniquely individual interpretation. A personal signature demonstrates what you see. The aim is to make your own efforts speak. By working in this way, your style will develop naturally.

Experiment with various materials and take your time exploring techniques. Apart from the basic knowledge, there is no specific way you are obliged to hold a pencil or handle oil paints, although there is a wealth of historical and contemporary techniques available for you to investigate. By learning them and trying them out, you will develop your own preferences for using colour, the material for your painting surface and the way in which you draw and paint. It's wonderful to use painting and drawing materials to create the effect you want. A technique belongs to you; it should not enslave you. What is unique to your work is your own vision and your personal signature in your paintings. Your passion gives depth to your work. Technology is simply a tool, an extension of your inspiration. It gives expression to your impressions.

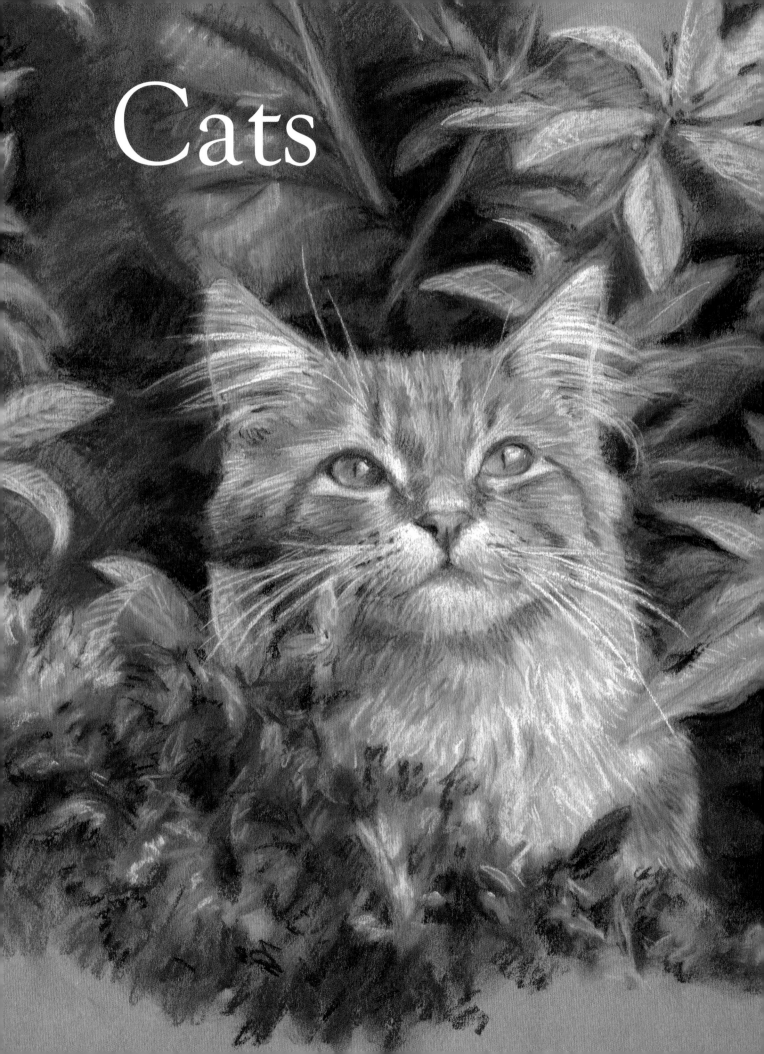

Cats

Cats are beautiful animals to draw. Full of character, they give the painter a reason to capture their gaze, mood and physical elegance in a painting.

Unlike paintings of wild cats in their natural environment, paintings of domestic cats have something of a human quality. We can recognise ourselves in them, can attribute human emotions to them, or enjoy their typical feline attitude. Wild cats seem to have a different look: they are instinctively sharp, ready to respond as a hunter, or to react to danger. The differences between wild and domesticated animals are interesting to study.

The paintings and drawings in this chapter are a selection from portraits that have been commissioned and my personal work.

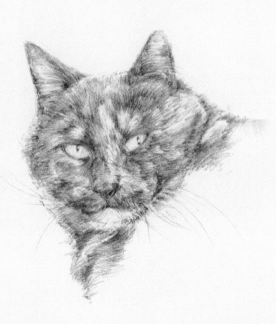

'Red Maine Coon', 50 x 40cm (19¾ x 15¾in), pastel on Mi-Teintes pastel paper

Inspiration

For centuries, cats have played a role in art, especially in an applied or symbolic way. If you need an example, just think of the wall murals and hieroglyphics of the Egyptians. In the seventeenth century, cats made a return to the scene as a decorative element, an afterthought, in portraits commissioned by their rich owners. The end of the nineteenth century changed the status of the cat to that of 'an animal with class'. It was in that period that Henriëtte Ronner-Knip became known for her paintings and drawings of cuddly kittens. In the period of 'La Belle Epoque', in Montmartre, Paris, you could not escape the *Le Chat Noir* poster art, created by Théophile Steinlen. At this point, the cat was more revered for its graciousness.

For every artist, the inspiration they have to paint cats is, of course, different. A characterful portrait of a house cat for its owner is something new, dating from very recently. As with human portrait artists, the aim of capturing the essence of their soul goes a step further than seen in previous cat art. In my own work, I recognise these different approaches to the cat in art by creating an eclectic melange. There is reverence for their soft and elegant appearance and the typical 'being', full of character. Sleeping, playing, discovering and sometimes just being funny. You can almost drown in those deep feline eyes. But I also like to go beyond an illustrative approach to capture their subtle

This little kitten is fast asleep after a long time spent playing. The fact that she is far away in dreamland is in contrast to the busy pattern and bright red colours surrounding her. Because of this, she seems even more cut off from her surroundings. By not placing the kitten centrally, the gaze of the observer is directed around to the pattern on the cushions and then back to her, inviting this participation in the story.

'Misu', 18 x 13cm (7 x 5in), oil on panel

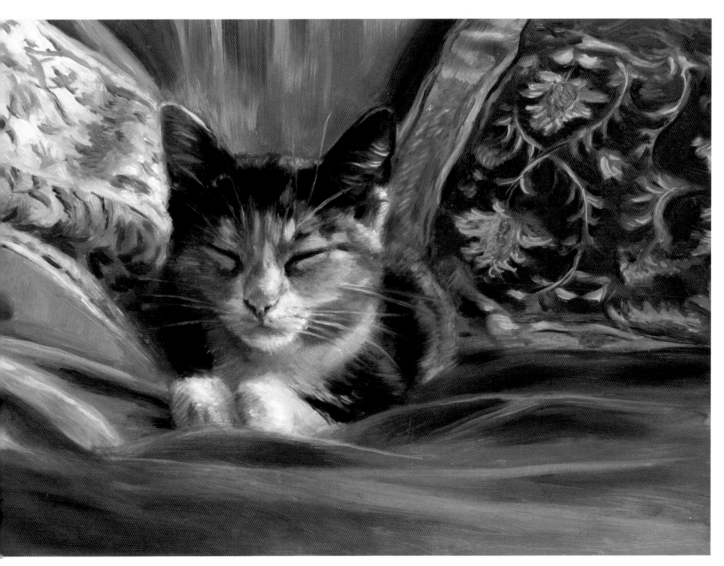

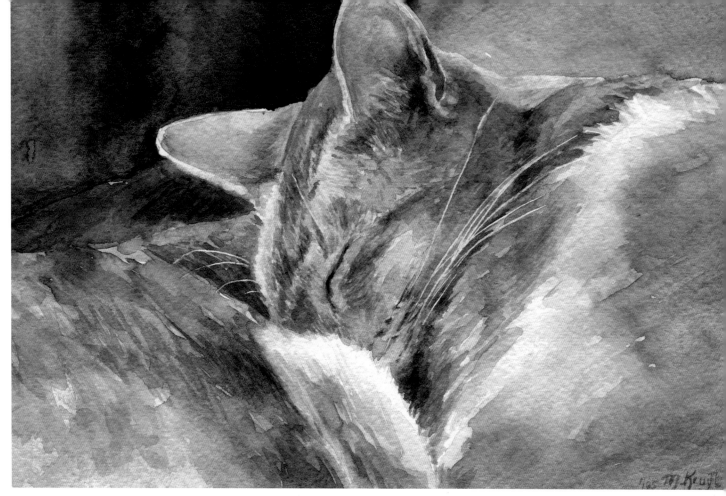

'Yoda' – Oriental Shorthair, 19 x 13cm (7½ x 5in), watercolour

sophistication in a piece of work that is also about atmosphere and strong composition. The standpoint of the observer is that of a spectator, whom the cat (immersed in their own mysterious world) views. Catching the inner animal on canvas, going beyond technique, and seemingly beyond realism, gives me the most satisfaction.

I can watch my own cats endlessly. Yoda sleeps peacefully, with her tail over her nose. She can never be warm enough and therefore feels quite happy sleeping in her wool basket, in full sunshine, during a heatwave! Her quiet, warm presence was the inspiration for this watercolour.

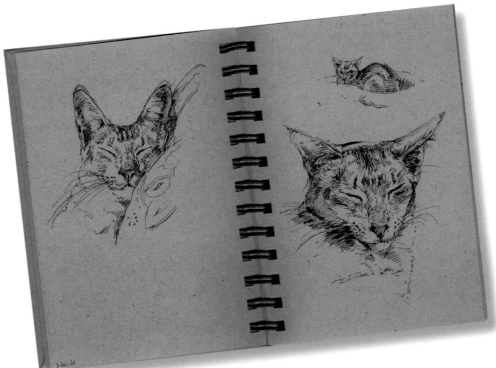

Sketchbook in ink

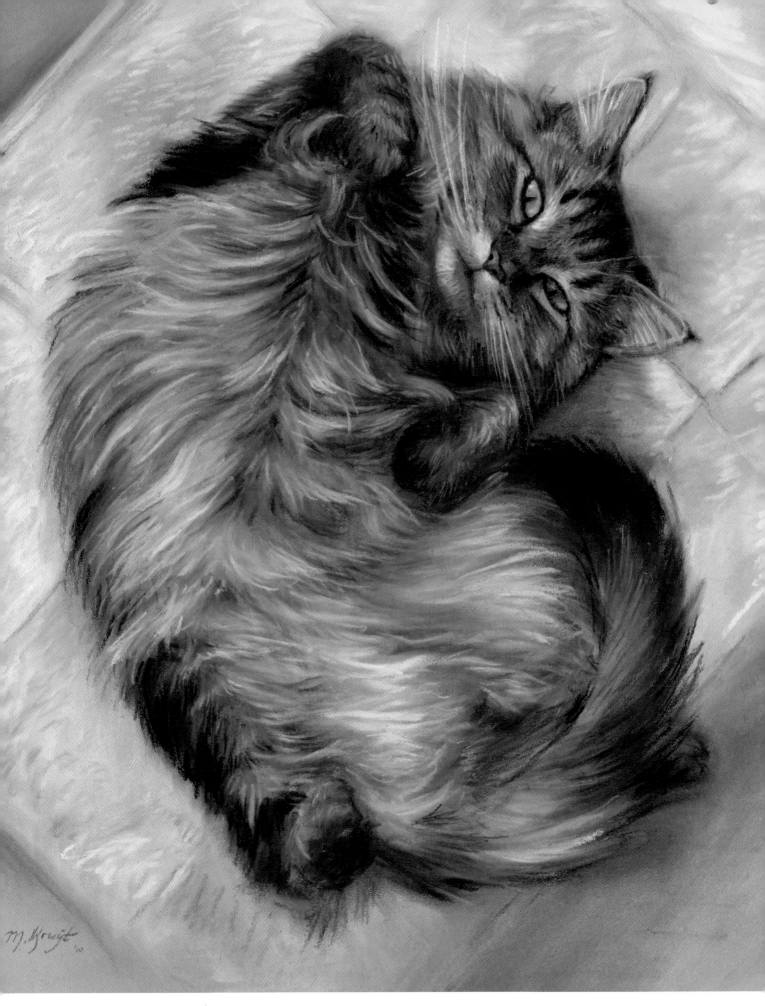

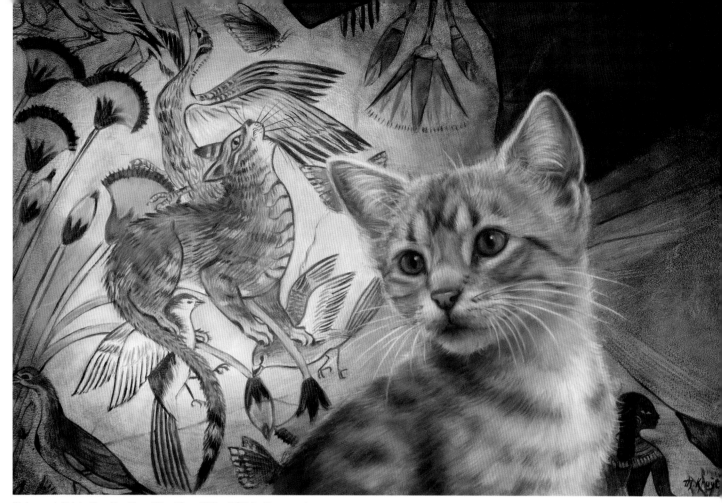

'Nebamun's Tale' – Egyptian Mau, 60 x 40cm (23½ x 15¾in), oil on panel

My interest in animal symbolism can be seen in this painting. The fragment is of an Egyptian wall painting from the tomb of Nebamun, where a cat catches birds at the side of a fisherman. This is one of the oldest examples of the connection between man and cat. In this painting, it is almost as if I have made the contemporary Egyptian Mau understand this memory, with the butterfly (a symbol of freedom) resting on her back.

To the right of the Mau, you can just see a human figure who is showing respect to nature. This painting could be seen as a timeline from the left to right: from the past to present day. Even though she is now largely domesticated, the respect that a contemporary cat receives from her master can be reflected within.

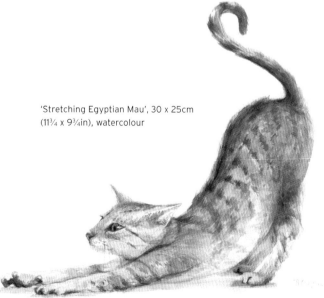

'Stretching Egyptian Mau', 30 x 25cm (11¾ x 9¾in), watercolour

< 'Rolling Maine Coon', 40 x 50cm (15¾ x 19¾in), pastel on Colourfix

The craziness and humour of cats are very inspiring. It's as if they were born to do it. The invitation to stroke this furry belly was quickly taken up. The long coat is made up of multiple layers of pastel – compare this with the 'Norwegian Forest Cat' demonstration on pages 126–131.

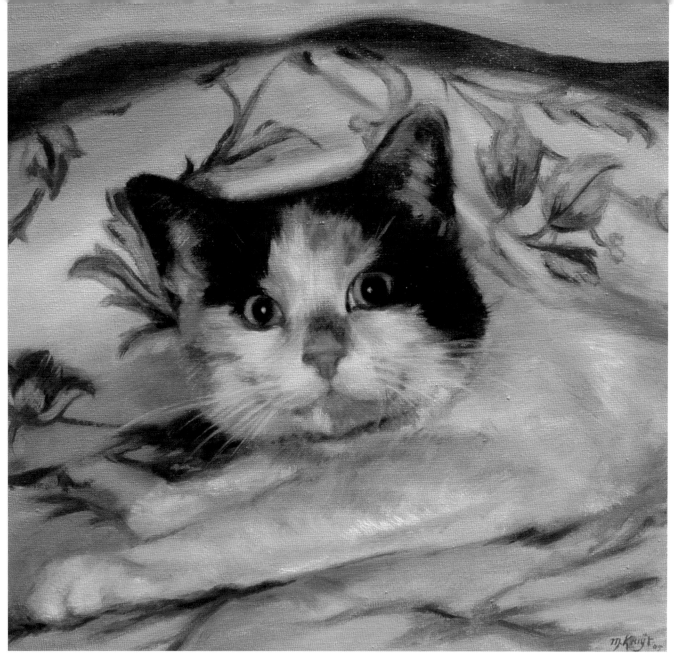

'Under the Blanket', 30 x 30cm (11¾ x 11¾in), oil on canvas

Caught under the duvet – one of the favourite places for a cat to hide away. The gaze of a cat is largely determined by the size of its pupils. The large pupils here give the cat a playful look, ready for action.

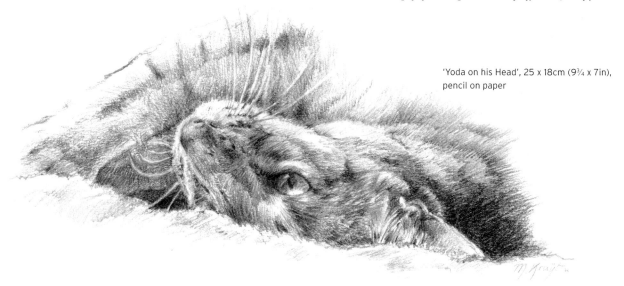

'Yoda on his Head', 25 x 18cm (9¾ x 7in), pencil on paper

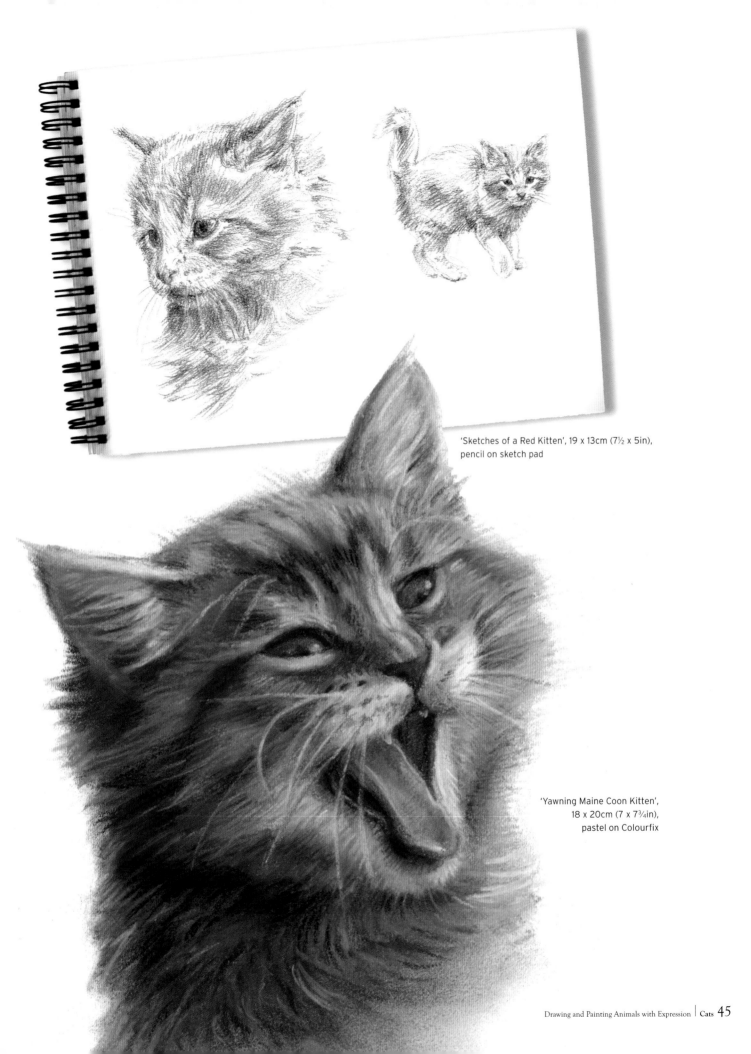

'Sketches of a Red Kitten', 19 x 13cm (7½ x 5in),
pencil on sketch pad

'Yawning Maine Coon Kitten',
18 x 20cm (7 x 7¾in),
pastel on Colourfix

Using space and backgrounds

How do you create a feeling of space in a painting? What can you do with the backgrounds, with the choice of colour and light? How do you combine photographs?

In a painting, it is possible to give the impression of space by positioning the cat in a certain way within an environment. This results in distinct foreground, midground and background areas, and creates overlaps.

A good choice of light is also important. The coat of a cat that has been lit by a camera flash will appear flat and unnatural. A cat that is flatly lit will appear less three-dimensional than a cat that is lit at an angle. Observing how light falls on the fur, like a cat sitting in the garden or sleeping on the couch, can be really instructive. Once you get to know the physical characteristics of a cat really well – by drawing them a lot and studying their anatomy – then it is easy to incorporate light into a painting.

My cat, Balou, keeps a close eye on where I am and follows me everywhere in the house – mostly for lots of cuddles. I have chosen this composition so that the viewer's gaze is drawn to his eyes, deliberately leaving out the beautiful curve of his body on the left-hand side, to avoid distraction from the focal point.

The orange gives the background an element of playfulness, and it brings the quiet purple (its complementary, opposite on the colour wheel) more to the front.

'Balou', 20 x 20cm (7¾ x 7¾in), oil on canvas

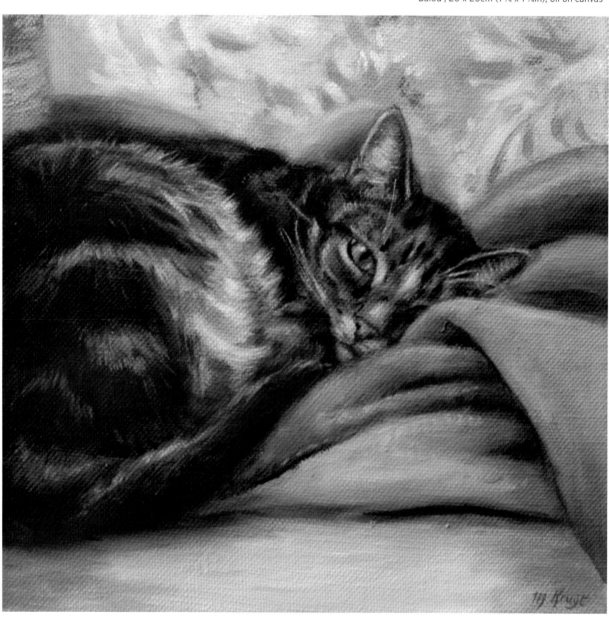

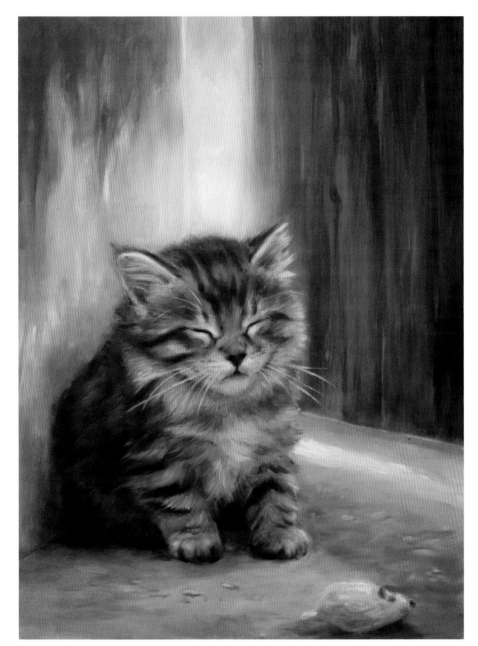

Light

I tried to draw this little kitten time and time again, but she was far too busy playing. After half an hour, she gradually fell asleep, and I could finally sketch her. I composed this painting with the aid of various sketches. Leaving out the original surroundings, I added a wooden door in the background to symbolise a route to dreamland. The playful little mouse, minus its tail, is a reminder of the fact that cats can just as cheerfully take on the role of hunter as they can house pet. I subsequently moved the mouse and painted it closer to the edge so that it doesn't distract too much from the kitten herself. The left paw of the kitten is placed slightly forwards in the direction of the mouse, as if they were in the middle of playing when she suddenly fell asleep. By placing the subject in one third of the space, it makes the overall composition more interesting. The compositional 'rule of thirds' is something you will see a lot in art. The slanted light on the ground adds a strong diagonal line to the composition and accentuates the space between the different areas.

It is interesting to understand how the paintings by the old masters are composed by taking a look at the viewing directions. The power of a painting lies largely in the composition. It determines whether there is a good use of space in the painting that will enhance the colours, light and atmosphere.

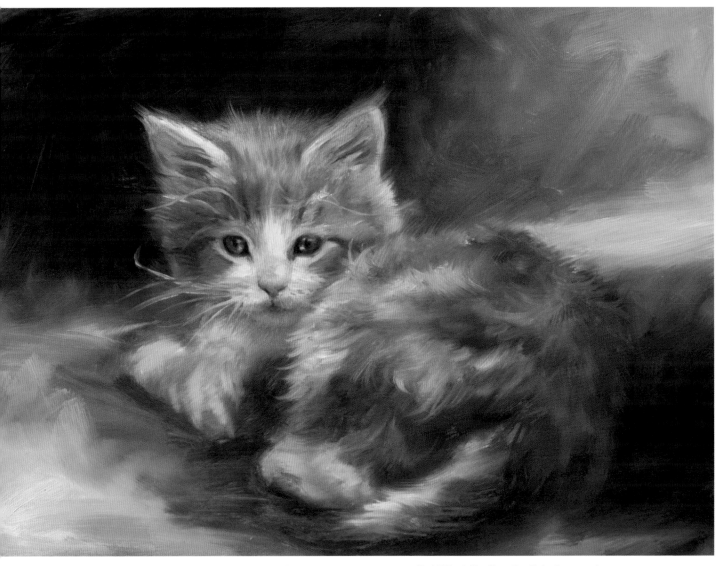

'Red Kitten', 18 x 13cm (7 x 5in), oil on panel

Colours

By using complementary colours – those opposite one another on the colour wheel – you can create a suggestion of more space in a painting. Orange, for example, is directly opposite blue, so they reinforce each other. In this example, the orange kitten advances in the painting, appearing closer than the blue background. It is interesting to use the effects of complementary colours in a painting. You can also use warm and cool colours next to each other when painting, like this warm-coloured kitten in cool, darker surroundings.

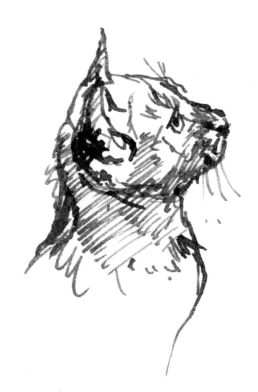

The gentle nature of this little kitten is reflected in the colours I have chosen. With white coats in particular, it is important to determine in advance what colour shade you are going to use, so that it complements it. Shadows on a white coat depend upon the colour of the light being used. Artificial light gives a white coat a warm yellow glow, while natural light gives it a cool, blue glow.

A pose that is at an angle provides substantially more space than a head-on stance. There are overlaps in the legs and the body.

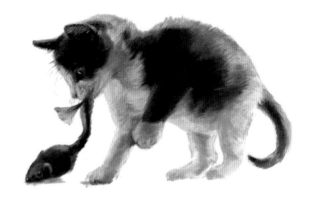

'Ginger-and-White Pussycat', 40 x 30cm (15¾ x 11¾in), pastel on Colourfix

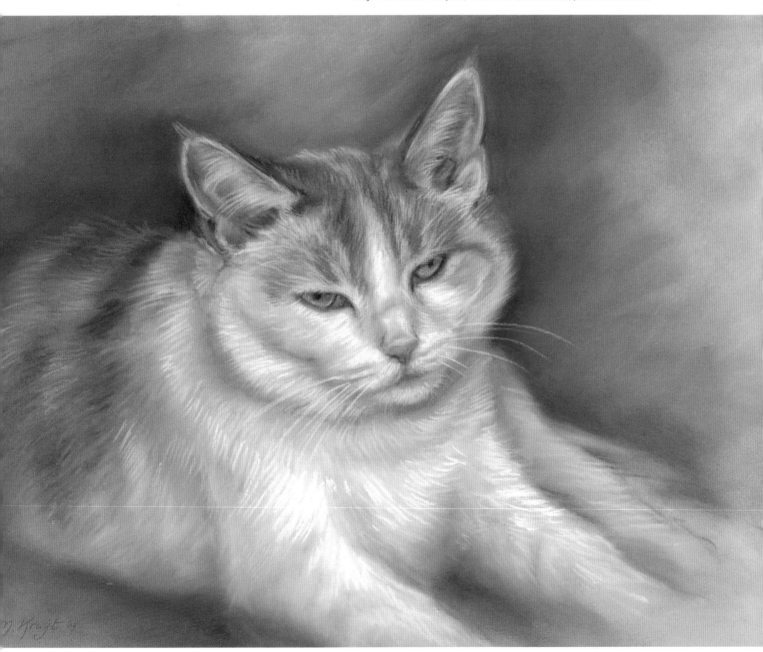

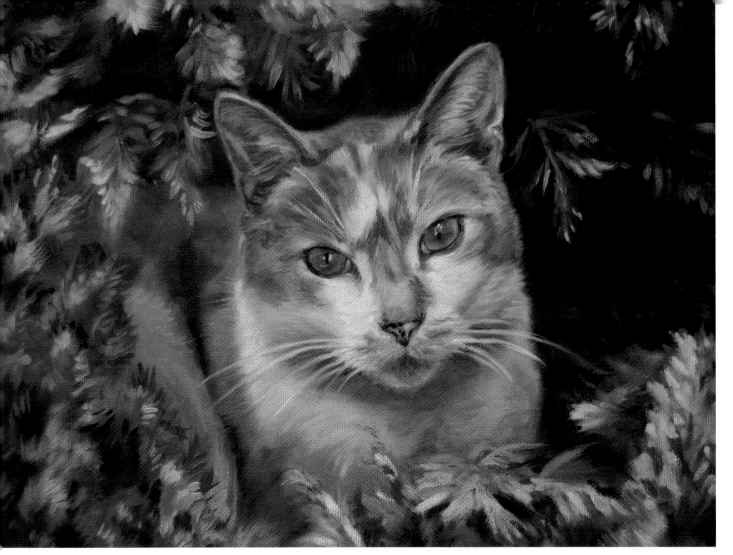

Backgrounds

In addition to adding prominent shadows to the coat, you can suggest depth in a painting through the environment in which the animal is placed. The cat above is positioned between the leaves of various plants, which are painted quite loosely, as though out of focus. The cat itself is sharper, and the attention is thus drawn to the eyes, creating a three-dimensional effect. The dark background behind the head makes it look as if the cat is coming out of the painting.

'In the Bushes', 30 x 24cm (11¾ x 9½in), oil on canvas

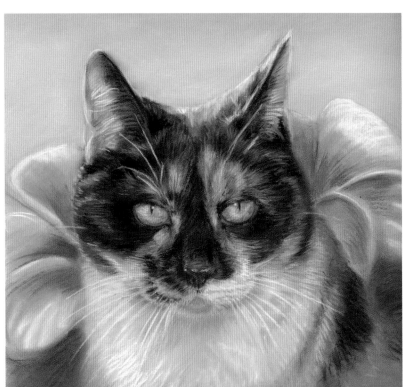

'Tortoiseshell', 30 x 30cm (11¾ x 11¾in), pastel on Colourfix

Behind this tortoiseshell cat, I have used a flower shape as a decorative element. I found that these colours and shapes matched the cat's characteristics. Because I never use empty decorative elements in my work, I did not want these flowers to divert attention away from the cat, but to complement her. I therefore ensured that the colour and shape of the leaves was close to the colour and curves of the coat. In addition, there is also a transition behind from yellow to pink, like a sunset. This is why the cat and the background go well together.

Combining more cats

When combining cats and backgrounds from different photographs, care must be taken to make sure that the lighting and colour of the light match. This also applies to the gloss on their coats, where this is pertinent.

Putting a cat that is viewed from above with a cat that is viewed at eye level gives a strange result, so make sure the viewpoints from which the photographs are taken match.

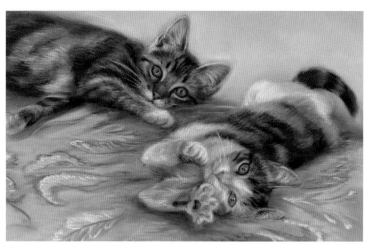

'Young and Playful', 50 x 40cm (19¾ x 15¾ in), pastel on Colourfix

This painting was created by merging different images. The first cat, as the lightest one, comes further forward. The grey cat is different and, optically speaking, is further back, because I have chosen a connecting blue background. Due to this match, the final composition looks as if it were created from a single initial image.

'British Shorthair and Ragdoll', 60 x 50cm (23½ x 19¾in), oil on canvas

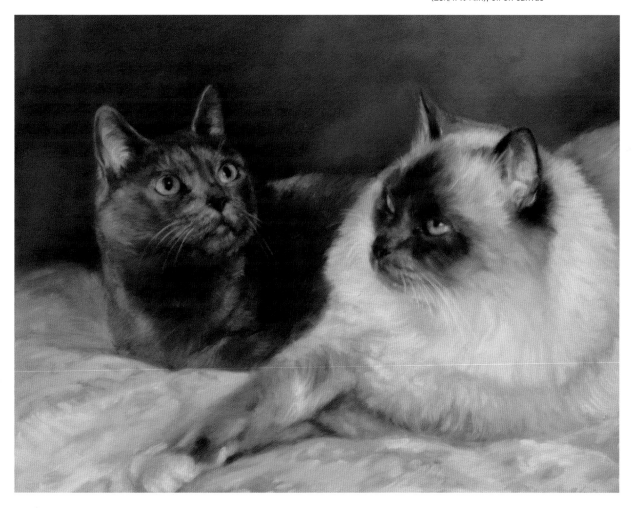

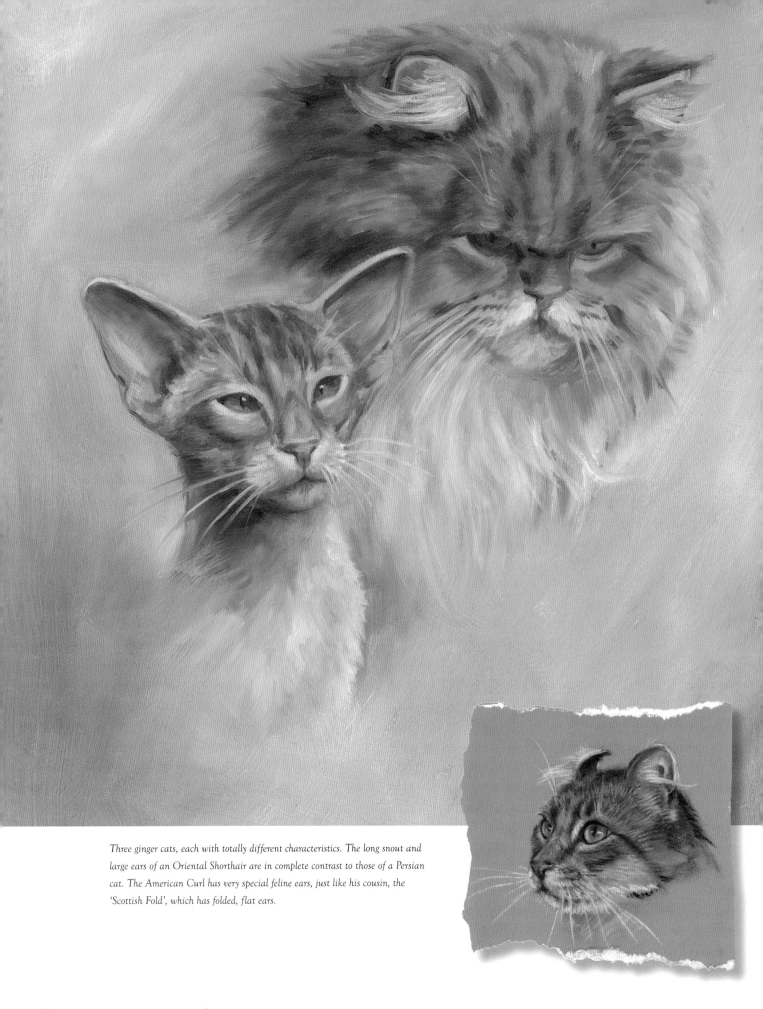

Three ginger cats, each with totally different characteristics. The long snout and large ears of an Oriental Shorthair are in complete contrast to those of a Persian cat. The American Curl has very special feline ears, just like his cousin, the 'Scottish Fold', which has folded, flat ears.

Anatomy and coat

Studies of ears and eyes are a good way to make every part of a cat individual. Noses and legs are also fruitful topics. With studies of the eyes, it is good to observe how light reflects from the curve of the eye and the way in which an elongated pupil changes.

Similarly, despite a simple triangle being the basic shape, cats' ears are quite complex in form. The rolling edge of the ear, the 'ear lobes', and the cartilage on the inside of the ear are key to a drawing that dazzles with anatomical accuracy.

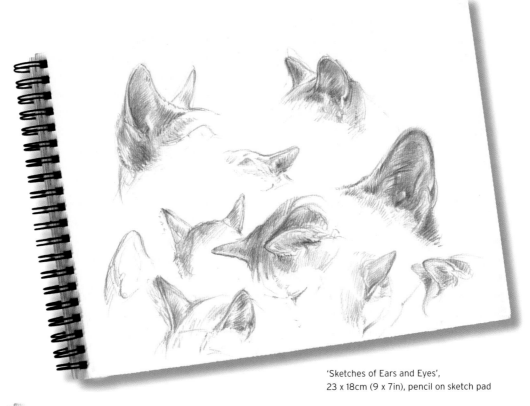

'Sketches of Ears and Eyes',
23 x 18cm (9 x 7in), pencil on sketch pad

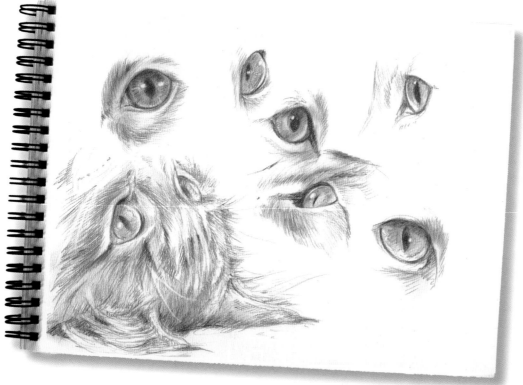

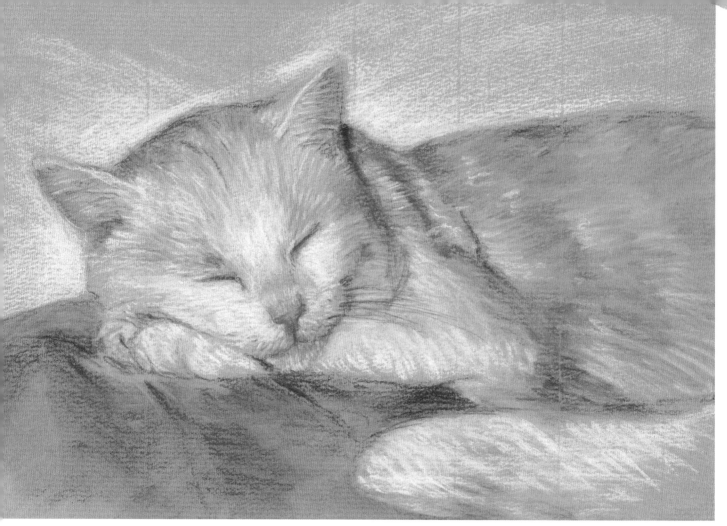

'White Cat', 30 x 20cm (11¾ x 7¾in), pastel on Mi-Teintes

Black and white coats

Whatever the colour of the fur, there will always be shadows, a sheen, and highlights (the brightest parts), the placement of which will depend on the lighting. Even a plain coat varies greatly. A white cat is only white in those sections where the light shines brightly. The rest of the coat is made up completely of shadows. A black cat lying outside in the grass will have a bluish sheen to their coat and, on a sunny day, the green reflection of the grass below will be visible. If a white cat lies on a red carpet, a pink glow will be reflected onto its coat from below. Lots of observation work will give you an insight into how the sheen affects a coat, so you can customise it if necessary.

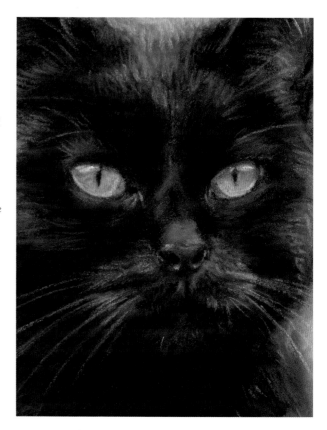

'Black Cat' (detail), 50 x 40cm (19¾ x 15¾in),
pastel on Colourfix

Long and short coats

With these two pastels of a Ragdoll and a Burmese, it is easy to see how the choice of paper is tailored to the type of coat. The Ragdoll, with its long hair, is drawn on Sansfix pastel paper. The sandpaper-like structure lends itself to blending the pastels, which soften the coat. The short-haired Burmese is drawn on Canson Mi-Teintes paper. The coat is drawn in short lines with pastel pencil, which, without too much blending, are then clearly visible on this paper.

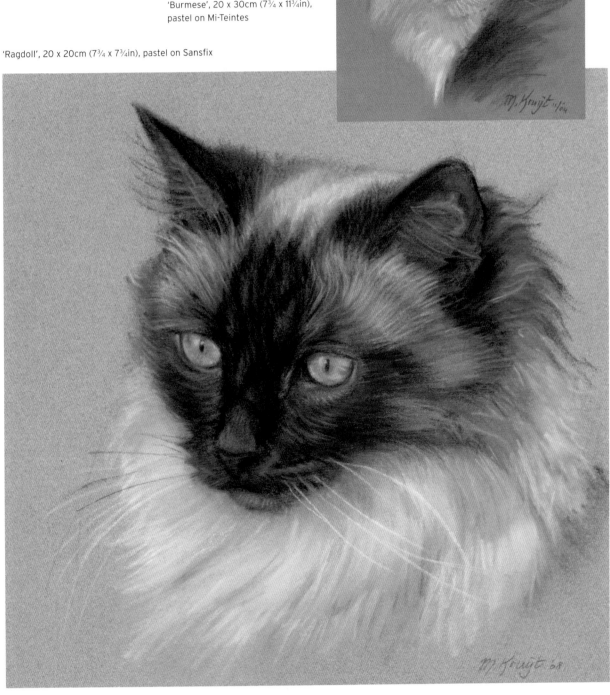

'Burmese', 20 x 30cm (7¾ x 11¾in), pastel on Mi-Teintes

'Ragdoll', 20 x 20cm (7¾ x 7¾in), pastel on Sansfix

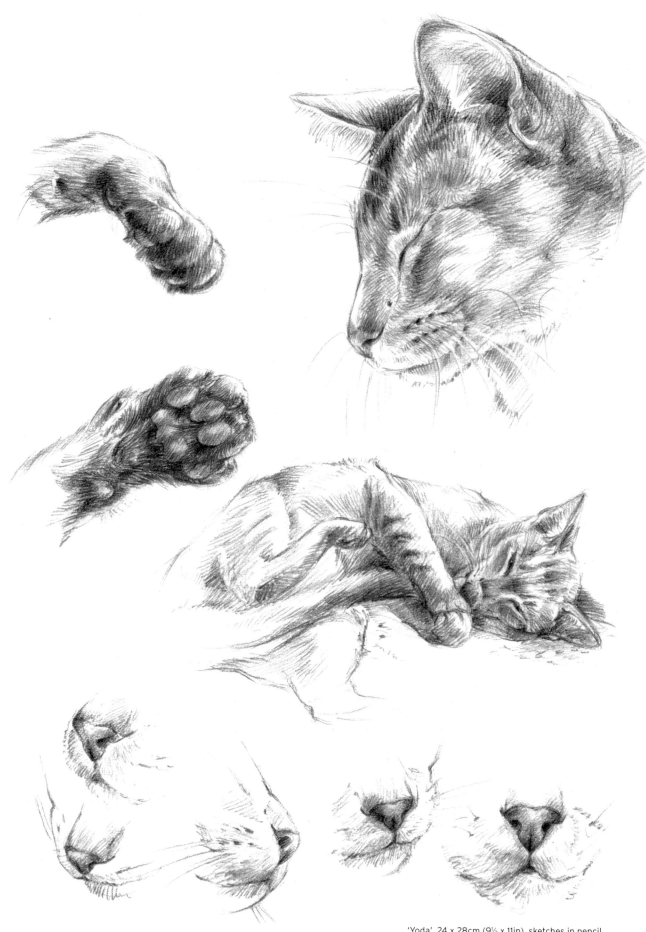

'Yoda', 24 x 28cm (9½ x 11in), sketches in pencil

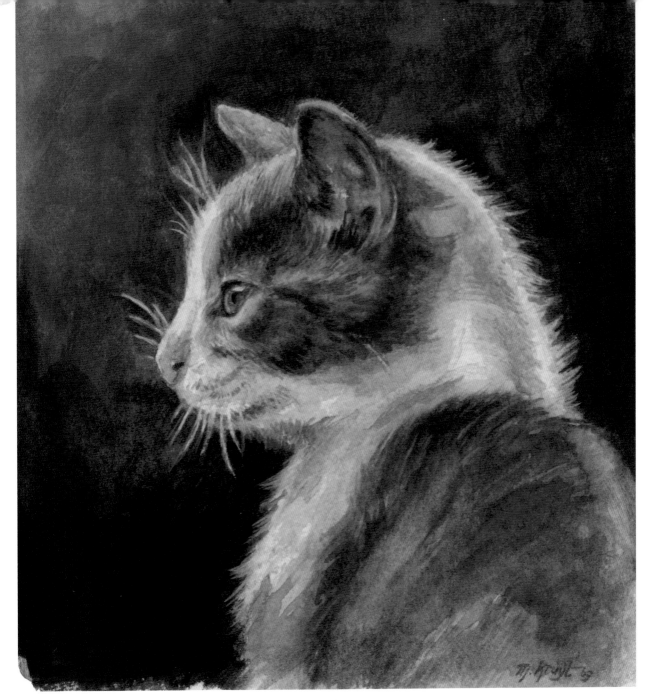

'Grey-White Kitten', 11 x 12cm (4¼ x 4¾in), watercolour on watercolour board

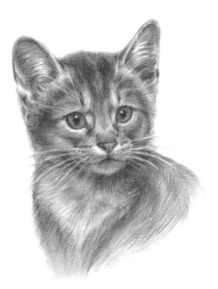

‹ On this sheet of studies and the painting above, you can clearly see how the direction of the coat goes over the head, as well as building up on the legs and from different points of view.

The nose can be simplified to a triangle, but from the side you can clearly see that it is spherical. Again, these are subtle differences which vary according to each cat and breed.

Breeds

Knowledge about the typical characteristics of various breeds is a good complement if you are painting a particular type of cat. Selecting for specific qualities in breeds has resulted in distinct breeding lines that share some qualities but are divergent in others. Here you can see a number of British Shorthairs with different poses and eye colours. Note that the shape of the head and even the size of the ears are completely different.

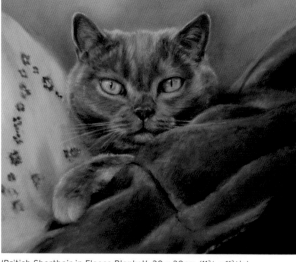

'British Shorthair in Fleece Blanket', 30 x 30cm (11¾ x 11¾in), oil on cloth

You can learn a lot by looking at the differences, especially if you want to correct something about the posture of the animal. The difference between a kitten and adult cat is clearly visible in the proportions. The eyes of a kitten are larger and, as with people, the forehead seems higher.

'British Shorthair Kitten', 15 x 20cm, (6 x 7¾in), acrylic on paper

'British Shorthair with Slipper', 30 x 25cm (11¾ x 9¾in), oil on canvas (detail of larger portrait)

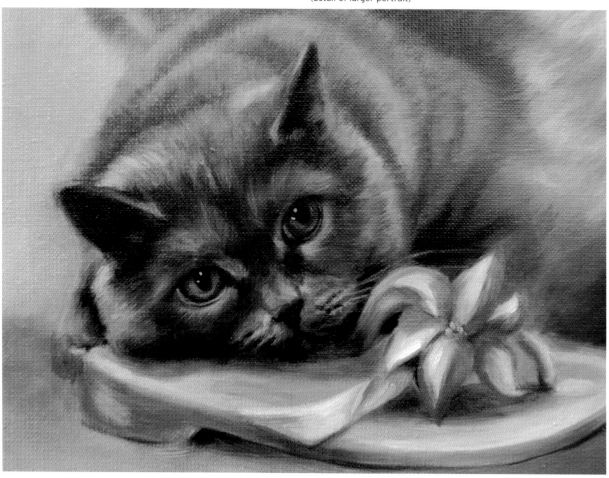

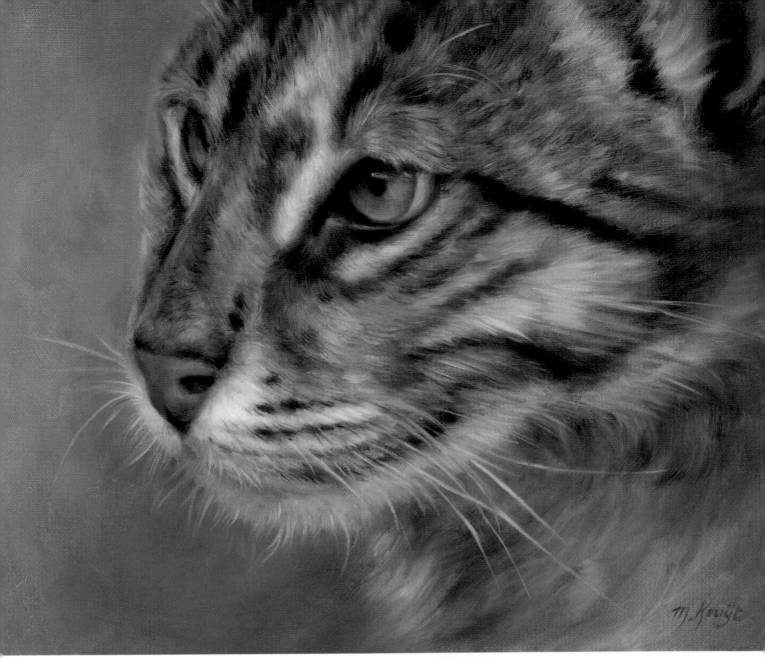

'Fishing Cat (*Prionailurus Viverrinus*)', 30 x 24cm (11¾ x 9½in), oil on canvas

This wild cat lives in the wild in South-East Asia and India. Ostensibly, it looks like a domestic cat, but there are major differences. In this painting, for example, it is plain to see that the nose bridge runs from above the eyes to the nose in a straight line, while our pet cats have a kink in the nose bridge. The typical 'tabby' markings on the head and the bright edges to the eye have not changed much.

'Kitten with Cuddly Toy', 11 x 15cm (4¼ x 6in), watercolour on watercolour board

Capturing characteristics in your sketches

How do you capture the essence of cats? How can you represent their suppleness and mobility in characterful poses? Everything starts with your empathy for the subject. What speaks to you in your sketches? Is it the beautiful curly coat, the crazy attitude in which the cat is lying, or simply a beautiful, elegant pose?

The domestic cat is a grateful subject. You can simply relax on the sofa and sketch whenever you want. At the same time, all your senses are enriched because you can touch, smell, and hear the subject, as well as walk around it, to see just how an ear is positioned. This is reflected in a sketch and eventually in the painting as well.

If I sketch an animal that will not stay still, I start multiple sketches at the same time, focussing on the basic shapes in each. Every time the cat changes position, I start a new sketch; and if it takes up an earlier position again, I return to continue working on that particular drawing. This creates a series of sketches of the cat in different poses.

Once you have got to know both the appearance and anatomy of cats, then you will be able to customise your drawings as you wish. Here you can see various studies made with a black ink pen, a fountain pen with sepia ink, charcoal, and watercolour.

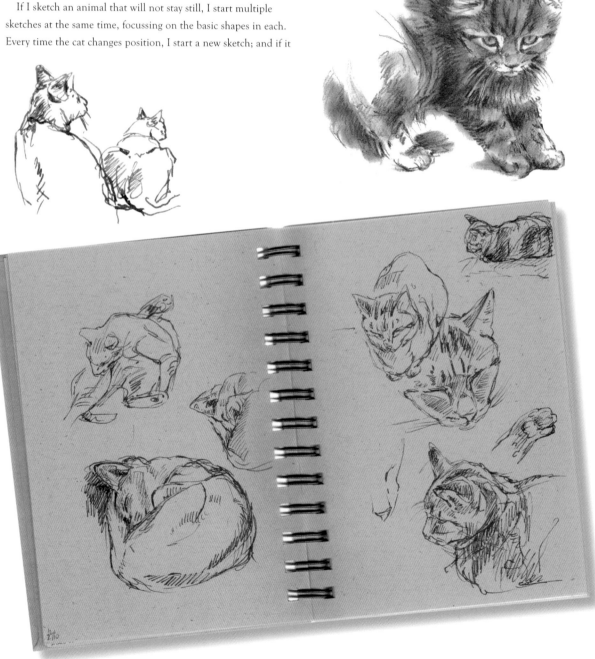

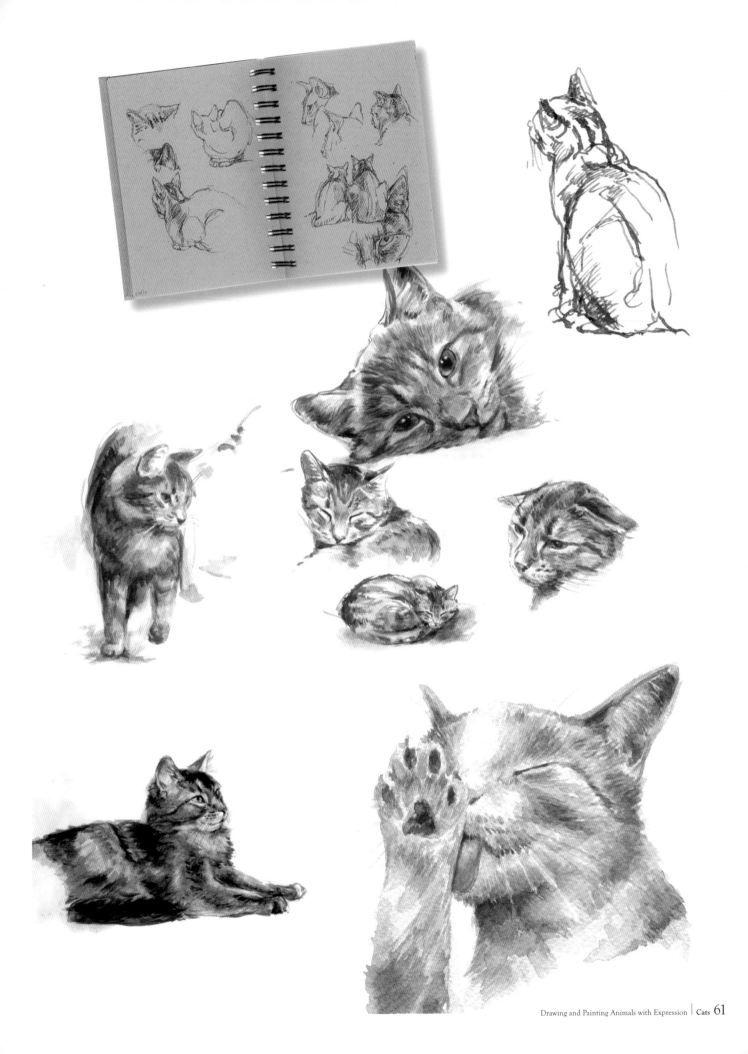

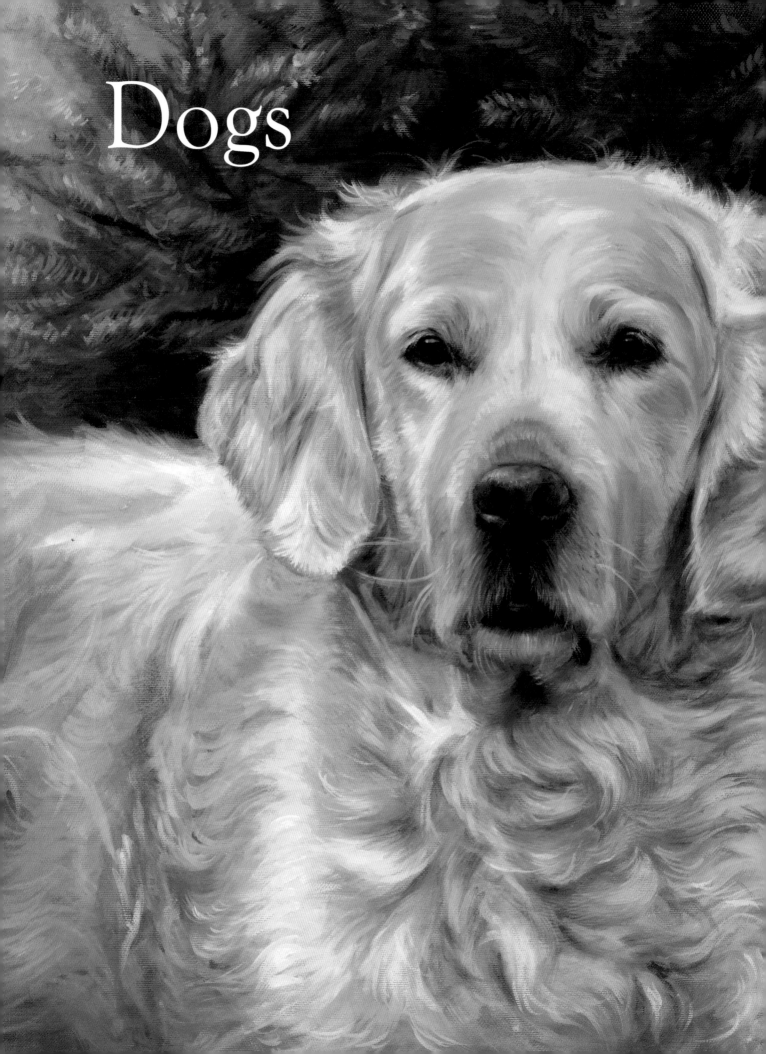

Dogs

Dogs come in all shapes and sizes: long- or short-eared, different muzzles, eyes, size and types of coat. Within breeds there is also great variety – the Golden Retriever pictured here has a beautiful and unusual white coat, for example.

It is enjoyable to draw dogs as they play in the park, forest or on the beach; and touching to see how they interact with one another. The innocent joy and movement of the dogs bouncing around is inspiring and is great to capture in sketches. I take a more personal approach when painting a portrait, which must ultimately capture the character of a specific dog.

The paintings and drawings in this chapter are a selection from portraits that have been commissioned and my free work.

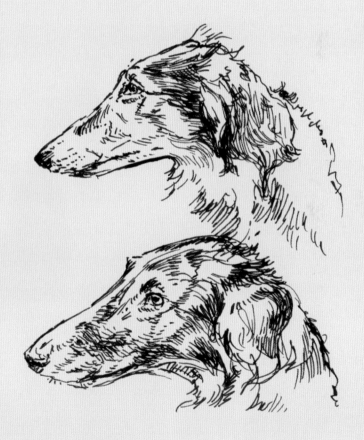

'Golden Retriever', 60 x 50cm (23½ x 19¾in), oil on canvas

Inspiration

The unconditional loyalty of a dog to its owner has inspired artists for centuries. In addition to their practical use as hunting or fighting dogs and companions, dogs have been seen as symbols of loyalty since ancient times, in cultures as wide-ranging as the Ancient Egyptians to the Celts.

Thanks to their dedication to man, some dog breeds seem very humanised. 'Another biscuit?' or 'I didn't do it' is clear in their facial expressions, which can be very endearing.

Painting a dog with or without surroundings has a totally different end result. If there is a serene background to the painting, then the viewer's attention automatically focuses on the subject, as is the case with a portrait. A charming moment, like a dog sleeping in its favourite place, can inspire me to do a painting of a dog in a particular environment. Here, it is less about character and more about an inspiring scene; about being full of beautiful light, creating an atmosphere or a memory.

'Kooiker Dog in the Woods', 50 x 40cm (19½ x 15¾in), oil on canvas

A dog in the woods seems gloriously in its element. It is as if it is saying 'Go and play outside and enjoy nature'. The warm colour of the dog's coat here is enhanced by a cool, light blue background.

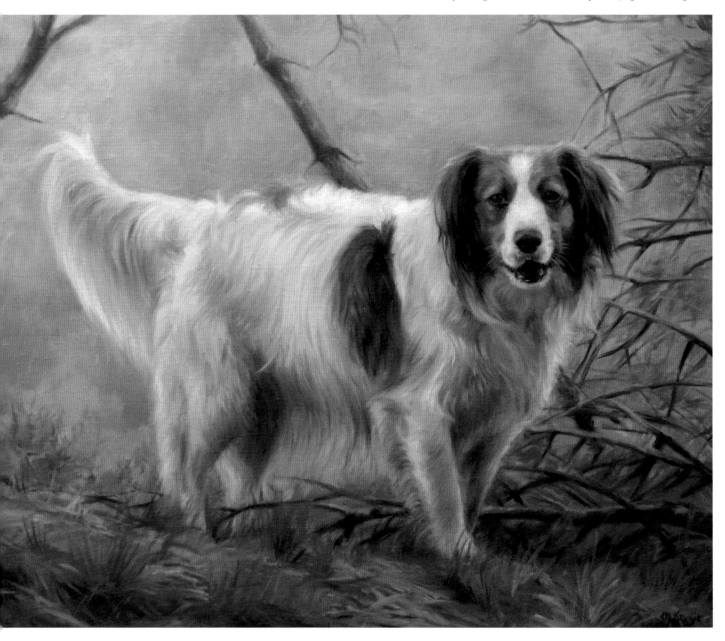

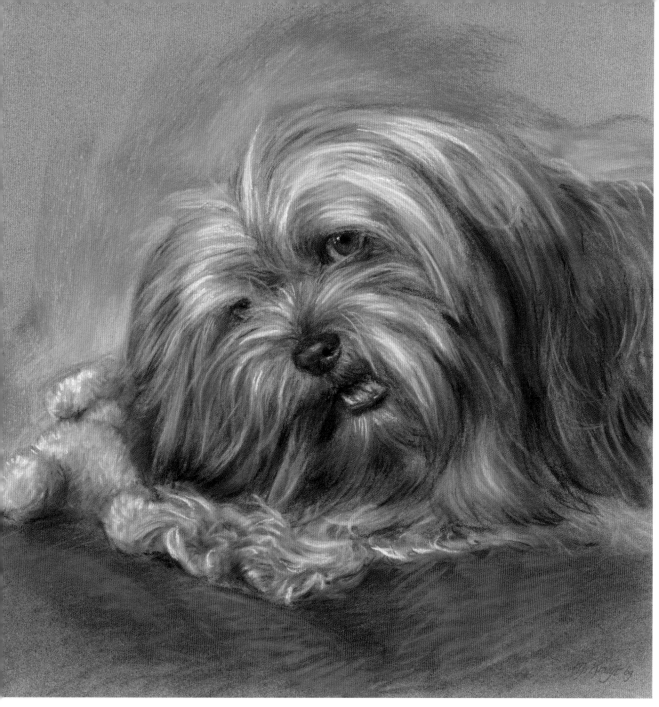

'Lhasa Apso', 30 x 30cm (11¾ x 11¾in), pastel on Sansfix

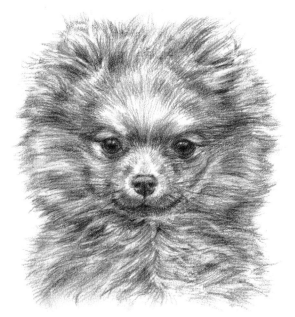

This dog bounced back and forth on the sofa, deliberately sweeping the long hairs over its head clownishly. Between its long locks, he peered at me with one eye, as though to say, 'I see you and I can keep an eye on you'. The red foreground symbolises this shy attitude, but his soft side can be seen in the light blue background. Enjoying his doggy treat, he only has eyes for the observer. He is uninterested in his own little bear.

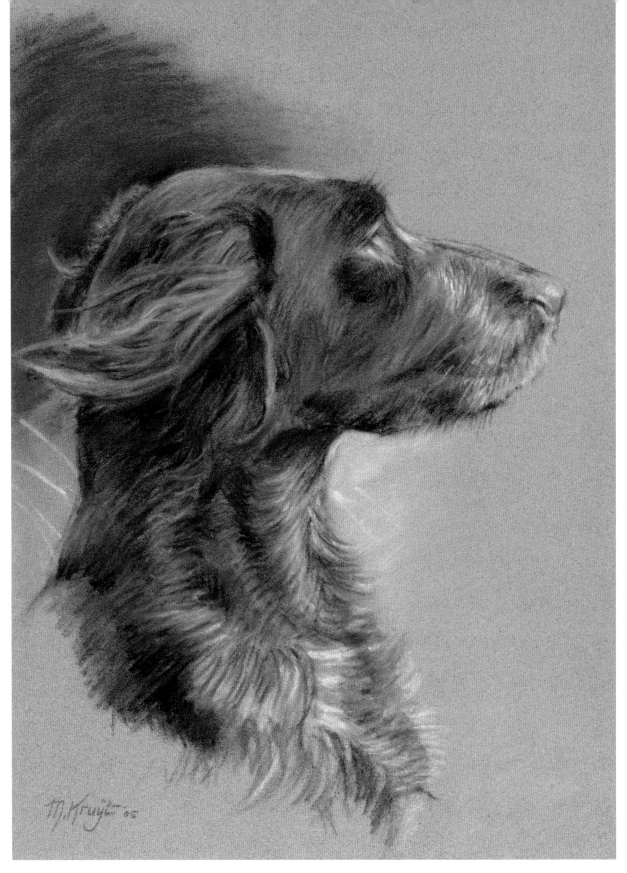

'Small Munsterlander', 20 x 30cm (7¾ x 11¾in), pastel on Sansfix

In this study I wanted to capture the attention of a hunting dog waiting for action. The ears flapping in the wind bring some movement and playfulness into the portrait.

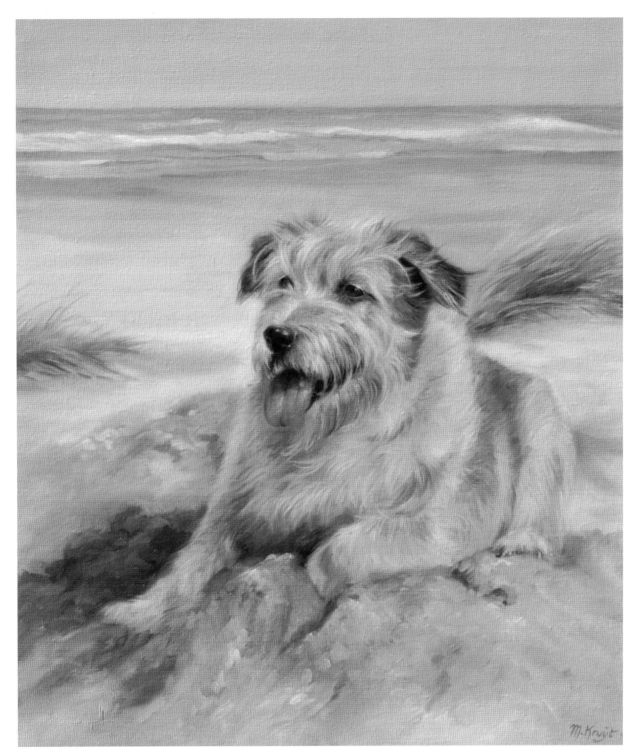

'Sea Dog', 50 x 60cm (19¾ x 23½in), oil on canvas

Dogs seem to go a little mad on the dunes by the sea. To bring this seascape to life, I added the suggestion that the wind is blowing through the flapping ears and swaying grass on the dunes. The crests of the waves of surf drift into the air. The viewing direction is guided by the diagonal line of the outstretched leg stuck in to the grass in the background.

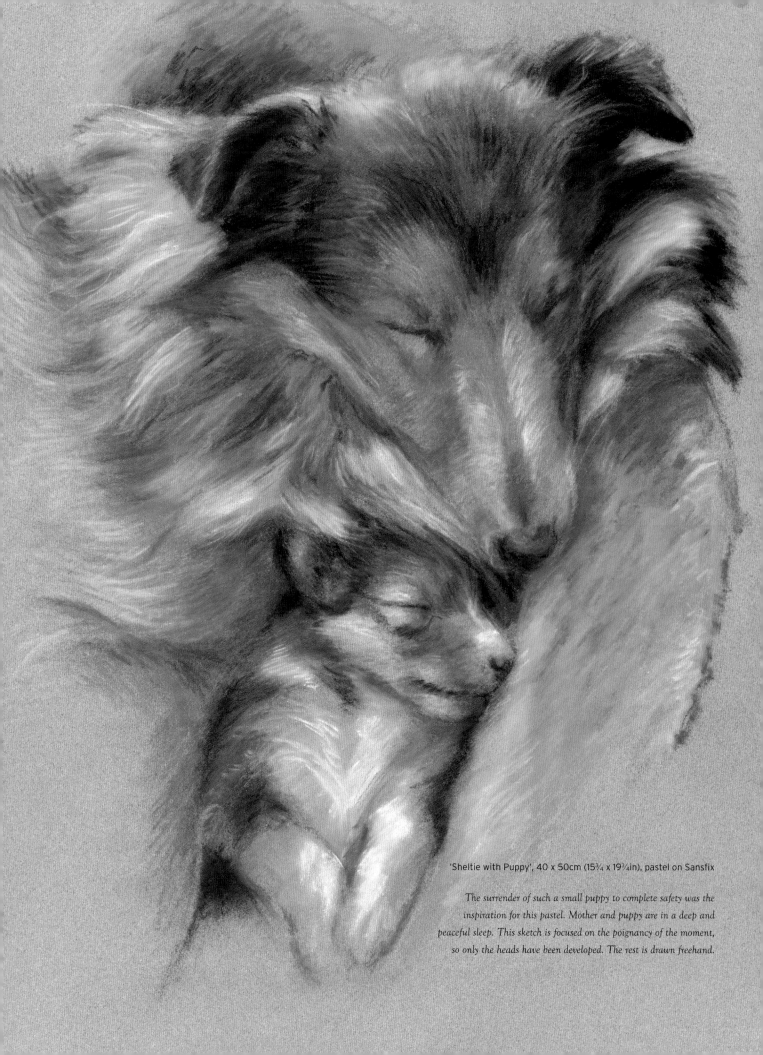

'Sheltie with Puppy', 40 x 50cm (15¾ x 19¾in), pastel on Sansfix

The surrender of such a small puppy to complete safety was the inspiration for this pastel. Mother and puppy are in a deep and peaceful sleep. This sketch is focused on the poignancy of the moment, so only the heads have been developed. The rest is drawn freehand.

'Karel', 40 x 50cm (15¾ x 19¾in), pastel on Colourfix

Every portrait has its own story. This dog was rescued as a pup after being badly abused on the streets of Greece. Once in the Netherlands with his current owner, he was surrounded by lots of love and has fully recovered. I was moved when I met him in my studio, and noticed that he was not wary or anxious around people, despite his past. I deliberately chose the inclined position of the dog in this portrait to create an atmosphere of geniality – his endearing, lovable character comes more to the fore than if he was looking directly at you. Karel seems to invite you to go and stroke him; exactly how he is in real life .

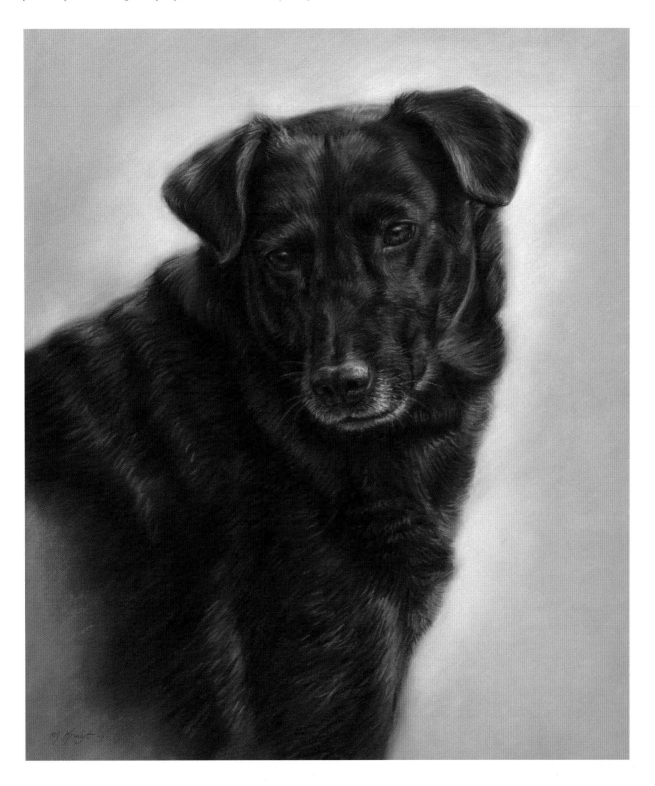

Using space and backgrounds

*How do you create a good composition? What influence do colours and light
have on the background and on depth? How do you combine photographs?*

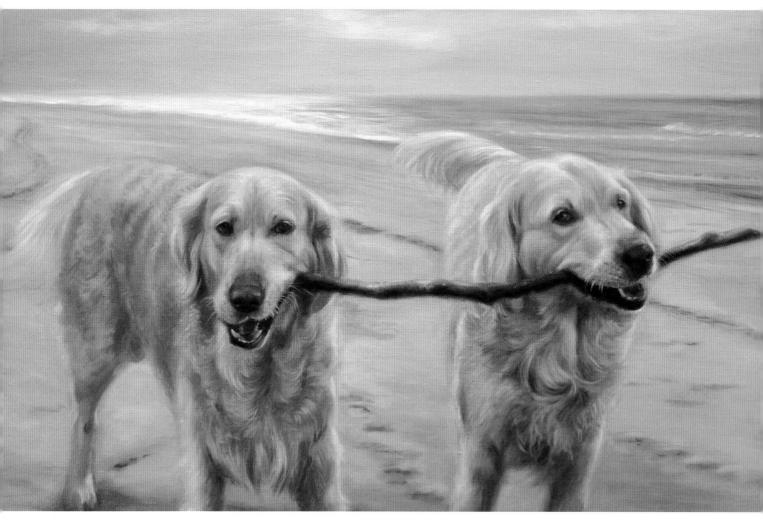

'On the Beach' – Golden Retrievers, 60 x 30cm (23½ x 11¾in), oil on canvas

Environment

*These two dogs are happy on the beach, so I added it as a background to this
double portrait, taken from the dogs in a different location. I had to adjust
the sheen on the dogs' coats, because of the position of the sun. The backlight
gives beautiful light edges along the coat, which creates extra space. If you
design something that combines elements from different sketches of
photographs, you must be careful to be aware of the true horizon in relation
to the position of the dogs. Here, the sea breaks through the horizontal
section with a diagonal line. The winding path on the left of the beach
makes you look back to the dogs and brings the composition in to balance.*

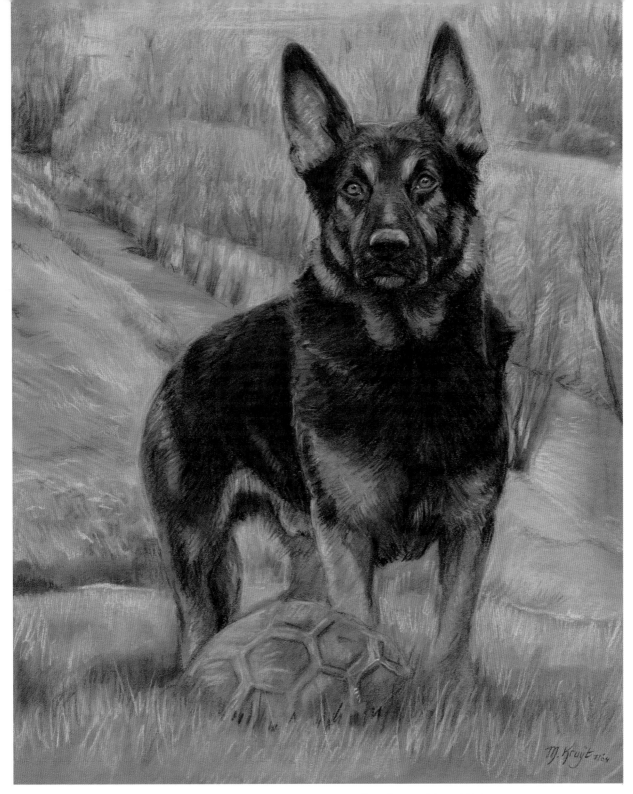

'German Shepherd', 30 x 40cm (11¾ x 15¾in), pastel on Mi-Teintes

The deep background gives this pastel a three-dimensional effect. As a viewer, you seem to stand high up in the landscape, with the slope behind the dog. The effect is enhanced by the contrast between the strong dark shadows in the dog's coat and the softer lighter-toned colours in the distance, which creates atmospheric perspective. Triangular composition (as shown in the inset) is classic in portraiture and provides a sense of balance and calm to a painting.

Light

The muzzle and tongue of this mischievous Sheltie come to the fore thanks to the sharp light that is coming from the left. The shadows this creates make the anatomy more visible, so that the shapes seem more three-dimensional. The blue and purple colours in the shadows contrast with the warm orange colour in the light. This is also known as 'hot–cold contrast'. The blue and orange colours are also found opposite each other on the colour wheel, which is called complementary contrast. It means that these colours reinforce each other as soon as they are placed next to each other.

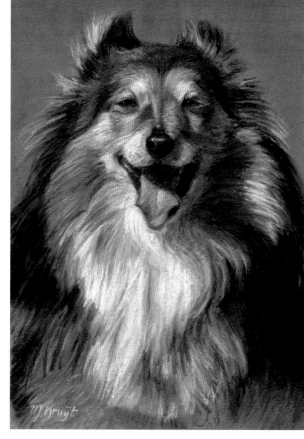

'Sheltie', 20 x 30cm (7¾x 11¾in), pastel on Mi-Teintes

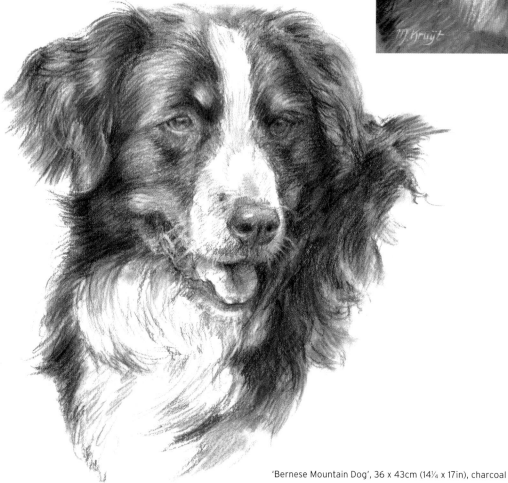

'Bernese Mountain Dog', 36 x 43cm (14¼ x 17in), charcoal

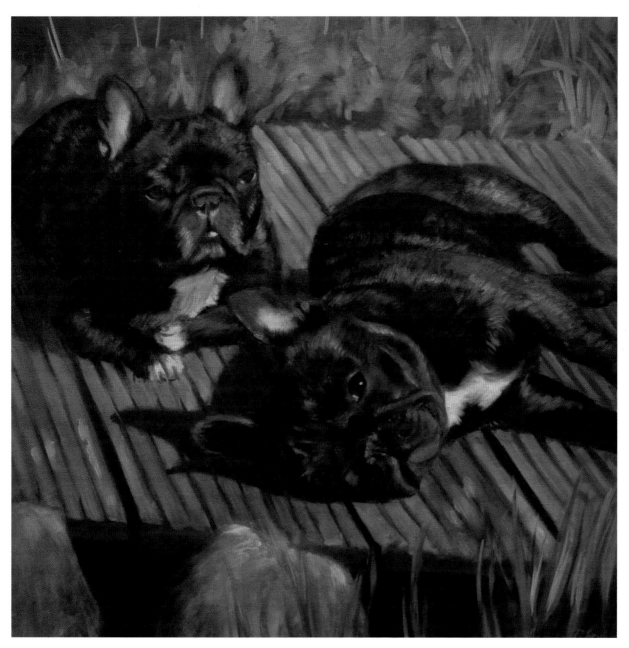

'French Bulldogs', 50 x 50cm (19¾ x 19¾in), oil on canvas

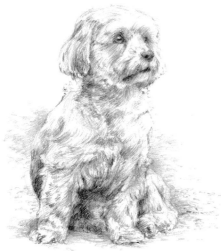

Compare this painting with that of the Golden Retrievers on page 70, which follows a similar theme. The French Bulldogs here are lit from the side, while the Golden Retrievers have a backlight. The glossy shine in the coat of the Golden Retrievers is therefore different. The light falls into the bulldogs' eyes from the side, making the colour of their eyes stand out. In terms of contrast, you can see that the darker dogs stand out from their surroundings against the lighter colour of the wood. You can see the reverse effect on the head and tail of the right Golden Retriever, where it is silhouetted against the darker surroundings of the sea. The French Bulldogs are composed at an angle: it is a design that delivers a sense of calm to the viewer.

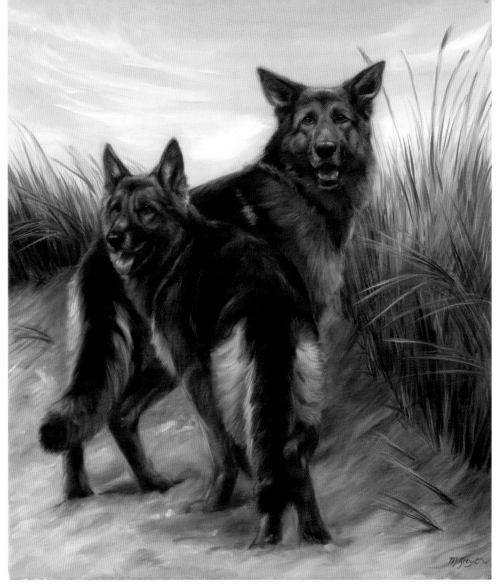

'German Shepherds in the Dunes', 50 x 60cm (19¾ x 23½in), oil on canvas

Combining multiple dogs

The painting above was created as a portrait and consists of various merged reference photographs. The heads were added separately from close-up portrait photographs, so I had to completely change the light on the heads and the colours in the coats. The details in the darker coat had disappeared in the photographs, but by later looking at a German Shepherd dog in my garden in the same position, I could observe the reflection of the sky in the coat, the tail and the anatomy of the back.

With the dogs completed, I then added the surroundings. Originally, the dogs were on a staircase, which I have replaced with a slope. That is why I made the choice not to show the sea, but only the dunes. I found that the curved stalks of the dune grass breaking through the static positions was an important addition.

'Alsatian', 30 x 40cm (11¾ x 15¾in), oil on canvas cloth

The profile of a German Shepherd is characterised by a long muzzle and pointed ears. As with a husky, you can see elements in common with the wolf.

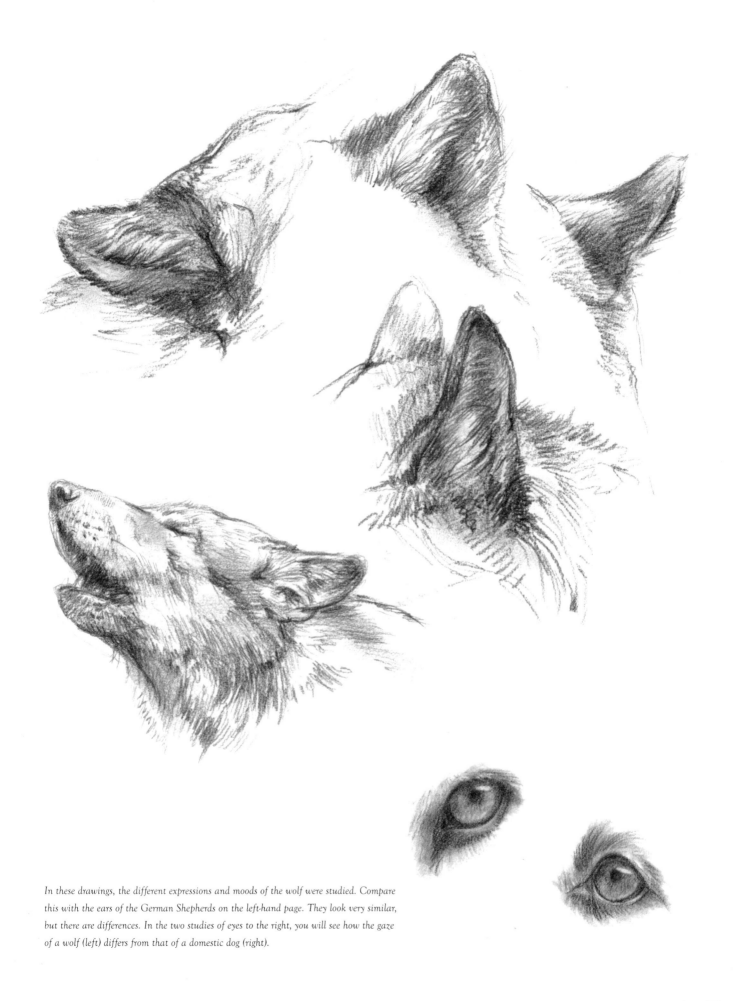

In these drawings, the different expressions and moods of the wolf were studied. Compare this with the ears of the German Shepherds on the left-hand page. They look very similar, but there are differences. In the two studies of eyes to the right, you will see how the gaze of a wolf (left) differs from that of a domestic dog (right).

Anatomy and fur

Space prohibits me from explaining all of the varieties of anatomy, ears, noses and coats you will find in dogs, but I can provide a small selection of some example characteristics that are common across a number of breeds. These include flat and long noses, upright and long ears, and some studies on how you can draw a tongue – including how they are shorter on different faces. By separately studying each body part of a dog in your sketch book, you will quickly learn the characteristic differences between breeds.

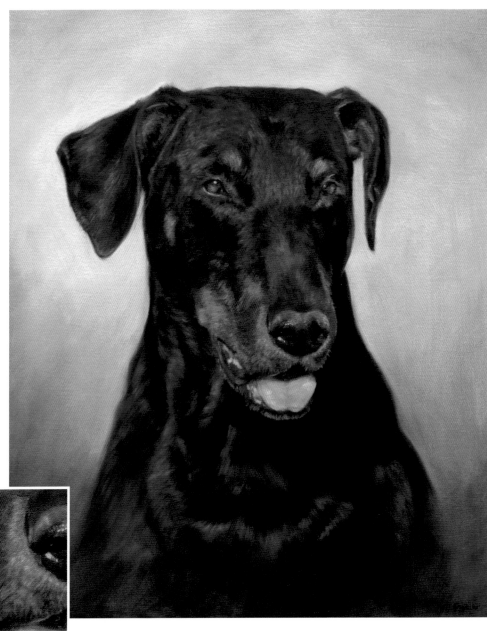

'Doberman' 50 x 60cm
(19¾ x 23½in), oil on canvas

The Doberman has a relatively long muzzle and a wonderful short, glossy coat. The painting technique for the coat is similar to that used for the rabbit in the demonstration on pages 132–135, but is built up from a brown underlayer. The 'black' is not a black from a tube, but a mix of deep brown and blue tones.

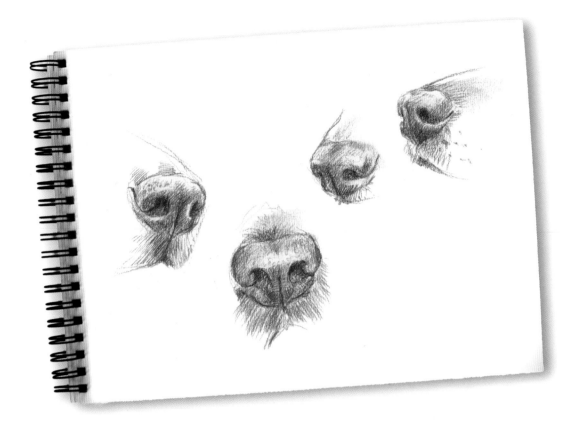

A nose consists of lots of curves, on top of a flatter plane. In these drawings, you can see that whether the noses appear shortened or less rounded will depend on the face of the dog.

Tongues can quickly appear unnaturally long and loose if you do not include the correct anatomy in the painting. A tongue is a muscle and can bend, hang, roll and curl. Because of the differences in thickness, dogs' tongues have many subtle curves and kinks. The tongue often hangs over the teeth as well.

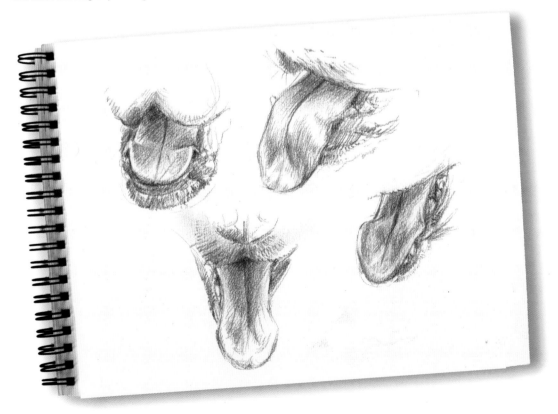

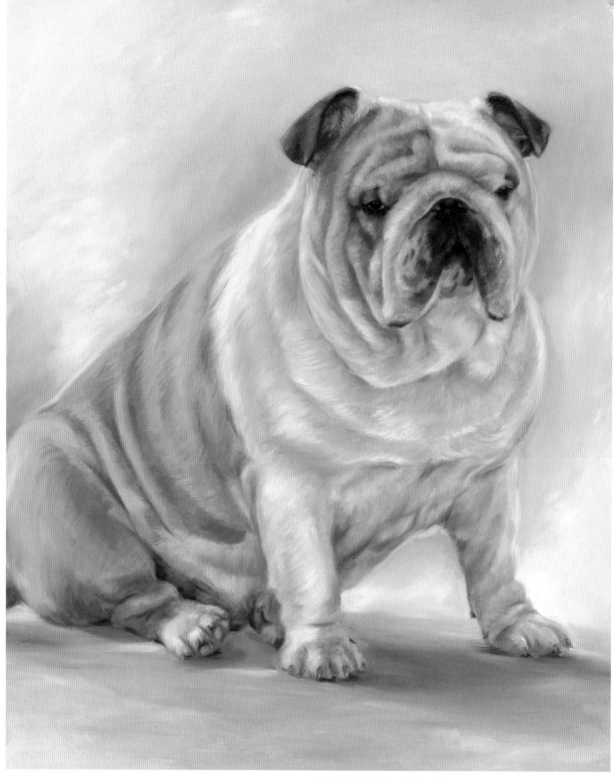

'Bulldog', 60 x 80cm (23½ x 31½in), oil on canvas

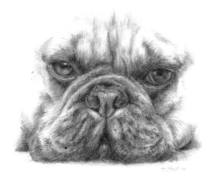

The muzzle of a bulldog is very soft. This is subtly suggested in the painting by the short hairs along the lips. The nose is often at eye level and is very flat. The construction of the body is solid, with relatively short legs. The ears hang, but they are not limp. As with the Doberman on page 76, the outer ear is firm and flips the tip of the ears forward. When painting dogs, you must pay attention that the stripe between the nose and lip runs in the right direction. In this instance, the muzzle comes forward, causing this split to tilt. In cats, this often deviates the other way, because the chin often sits more deeply than the upper jaw.

Breeds

There are many types of retriever. The best known are the Labrador and Golden Retriever. They can be very different in terms of form and the colour of their coat. The shape of the profile is clearly visible with retrievers, and is often very important for breeding lines. In addition to Golden Retrievers with a 'golden' coat, you also have lighter versions – this one here is white with more curls than usual, for example. In relation to the adult dogs, the puppies have big feet and their heads are much larger relative to the body.

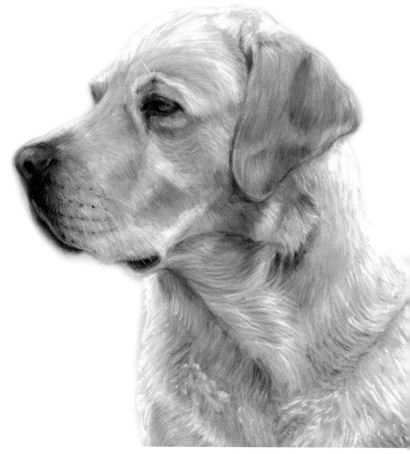

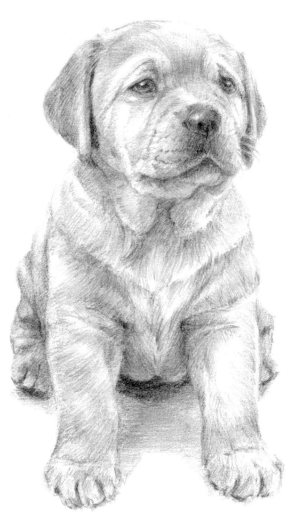

Pastel on Sansfix, 50 x 60cm (19½ x 23½in)

Pastel on Mi-Teintes, 50 x 40cm (19½ x 15¾in)

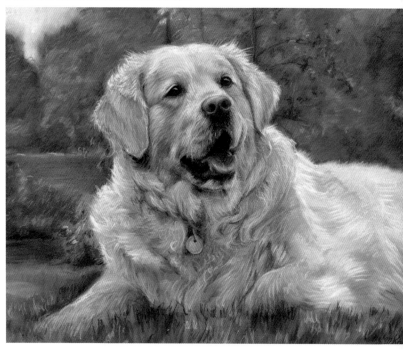

Pencil in sketchbook, 13 x 18cm (5 x 7in)

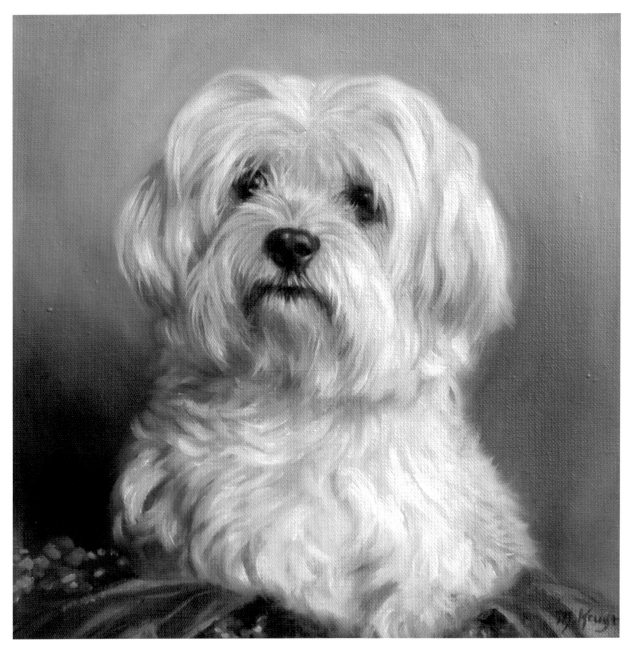

'Maltese', 30 x 30cm (11¾ x 11¾in), oil on canvas

Black and white coats

A reflection of the environment in the coats of white and black dogs is more visible than in those with a mottled coat. In the picture above, you can see the pink glow of the red ribbon reflected under the chin and in the fur. There is more shadow on the left-hand flank of the dog as a result of the light coming from this side. I have kept this as cool blue against the counterpart of the warm glow. In black coats, such as those of the Doberman on page 76, the sheen on the coat clearly illustrates where the light is coming from. Outdoor light often gives a blue sheen, whereas artificial light provides a warm, yellowish reflection.

'Cocker Spaniel with Ball', 15 x 15cm (6 x 6in), watercolour

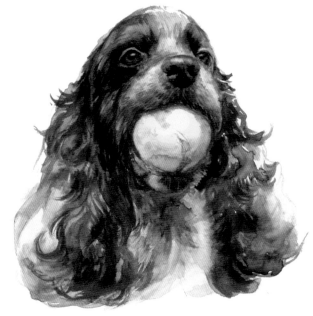

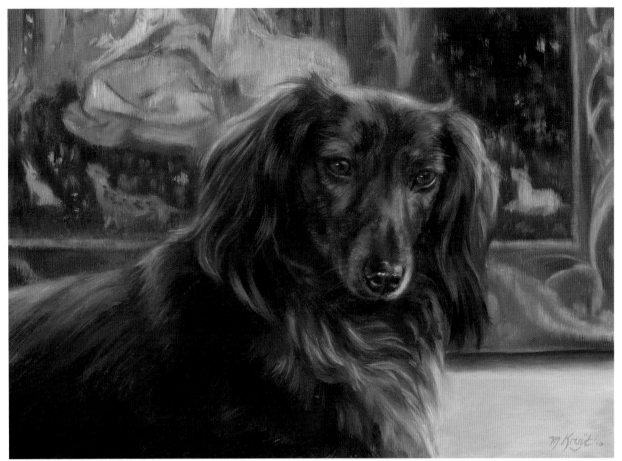

'Long-haired Dachshund', 24 x 18cm (9½ x 7in), oil on panel

Long and short coats

Two different Dachshunds, each in different lighting: one warm, the other cool. The lighting determines the choice of colour in a painting, and you can use this to intensify the atmosphere. By increasing the contrast, the Wire-haired Dachshund seems to have more sheen on his coat. In the cool, blue daylight, I chose blue strands for the Wire-haired Dachshund to transition to the dark shadows, and for the warmer colour, I chose orange strands along the muzzle and on the head. This way, the two complementary colours provide balance for the colour palette of the coat.

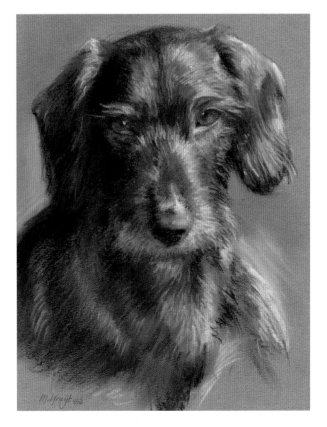

'Wire-haired Dachshund', 20 x 30cm (7¾ x 11¾in), pastel on Mi-Teintes

Capturing characteristics in your sketches

With flat, square pastel crayons, I set up the outline of this beagle. Ingres paper, named after the artist Jean-Auguste-Dominique Ingres, has a light structure made up of lines. You can see this in the background of the famous pastel drawings of ballerinas by the Impressionist artist Edgar Degas.

This paper does not take pastel well as it is relatively flat. That is why I worked in a single layer here. The excess pastel is lifted with a kneaded eraser, giving a little tooth to the paper.

'Beagle', 30 x 40cm (11¾ x 15¾in), pastel on Ingres paper

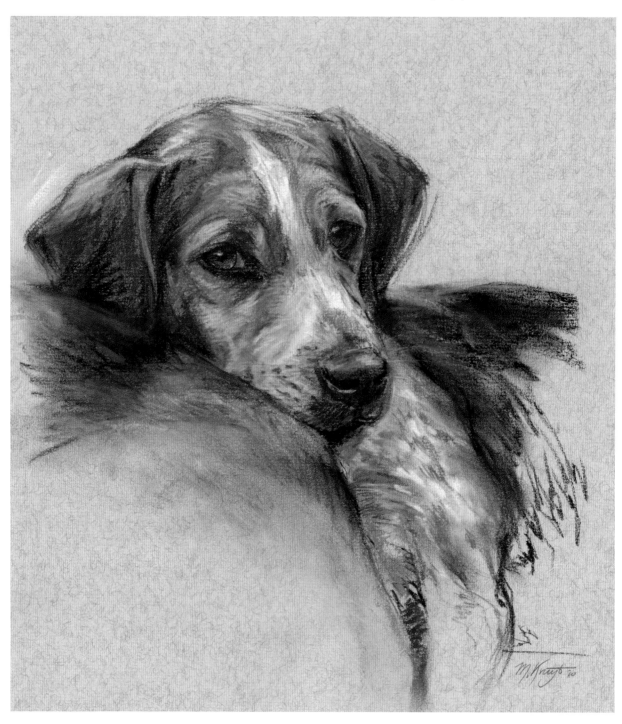

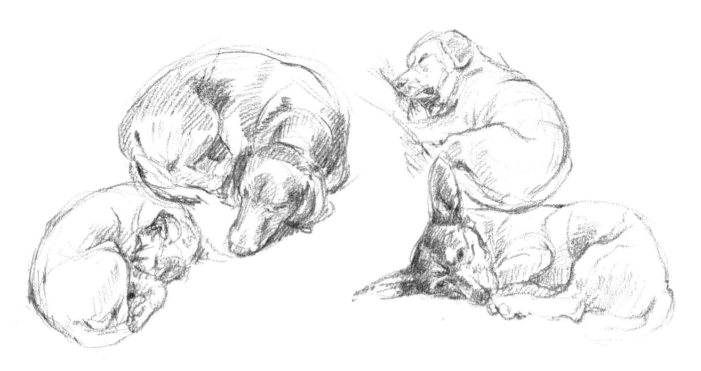

Sketching dogs is often easier than cats, because you can more often see them in a variety of outdoor and indoor locations, such as sleeping in their baskets (see above). This allows you to better observe their anatomy in different kinds of light. Sketches that illustrate movement take practice, and many sketchbooks are often full of scribbles, with only a few useful sketches. If you prefer sketching a sedentary dog, then pay attention to ensure that you do not lose any of the details. In the ink sketches of the Jack Russell below, I have looked at the anatomy and the coat direction. Because a dog is not always still, some lines are only half completed, but this can also be interesting. As long as the animal can sit before you, you can get to feel how the bones are and you can walk around them. This enriches your insight. You can find more about basic drawing techniques on page 25, in the chapter 'On location'.

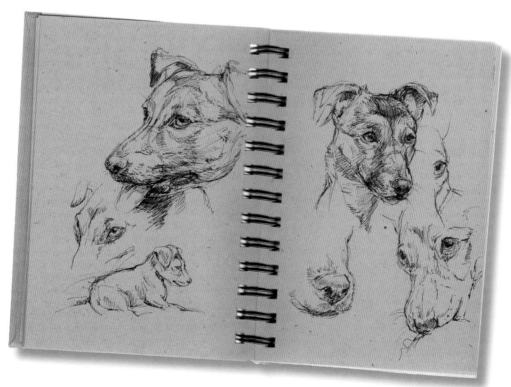

A dog in motion can tell you a lot about his character and mood. In the ink sketches on these pages, I focussed on capturing typical physical characteristics, such as the long noses of the borzoi and the shapes the Salukis make while running. The body of the moving, rolling dog demonstrates the anatomy of hips, chest and legs. The wrinkles of a Shar-pei are interesting to explore when sketching them. They make their heads very distinctive. The study of the Shar-pei pup in pastel (right) was done on Colourfix paper to bring out this texture.

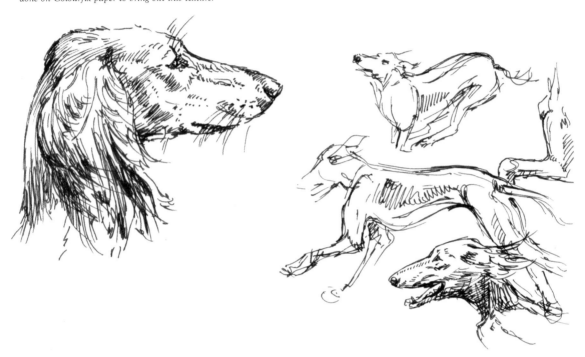

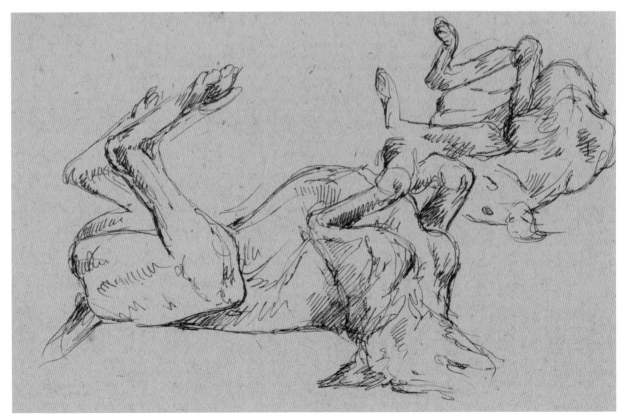

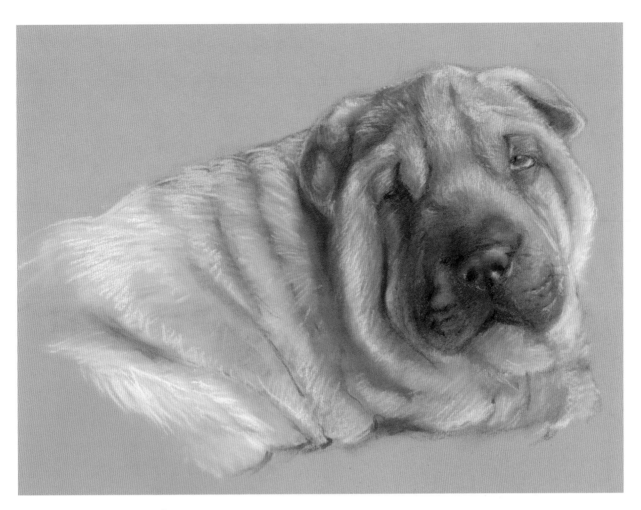

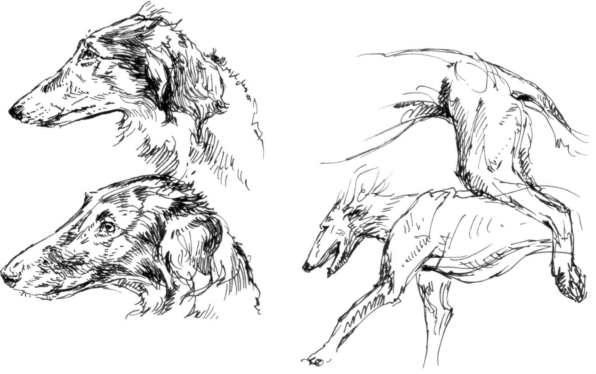

*A*nimals that are elusive in the wild can be seen in all their finery in contemporary wildlife art, something that was unthinkable in the past. Old masters such as Melchior d'Hondecoeter – one of my favourites – mostly had to work from dead and stuffed animals, as photography had not yet been discovered, and travel was expensive and fraught with danger. There is now the possibility, more than ever, to travel the world; to discover and observe animals in their natural environment, or see them at the zoo along with their little ones, too.

The old style of painting has a depth that is sometimes missing in contemporary wildlife art. This is mainly due to the problems that the artist had encountered in 'reviving' the animal on the canvas, placing the animal in a different position from the one in which it was set up. Creativity, inventiveness and imagination will automatically develop if you have a passion for animals, and especially where art is the motivation. This is also something that I try to maintain myself.

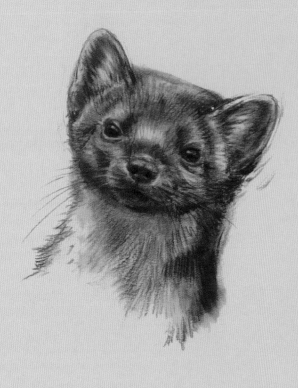

'Snow Leopard', 60 x 40cm (23½ x 15¾in), oil on canvas

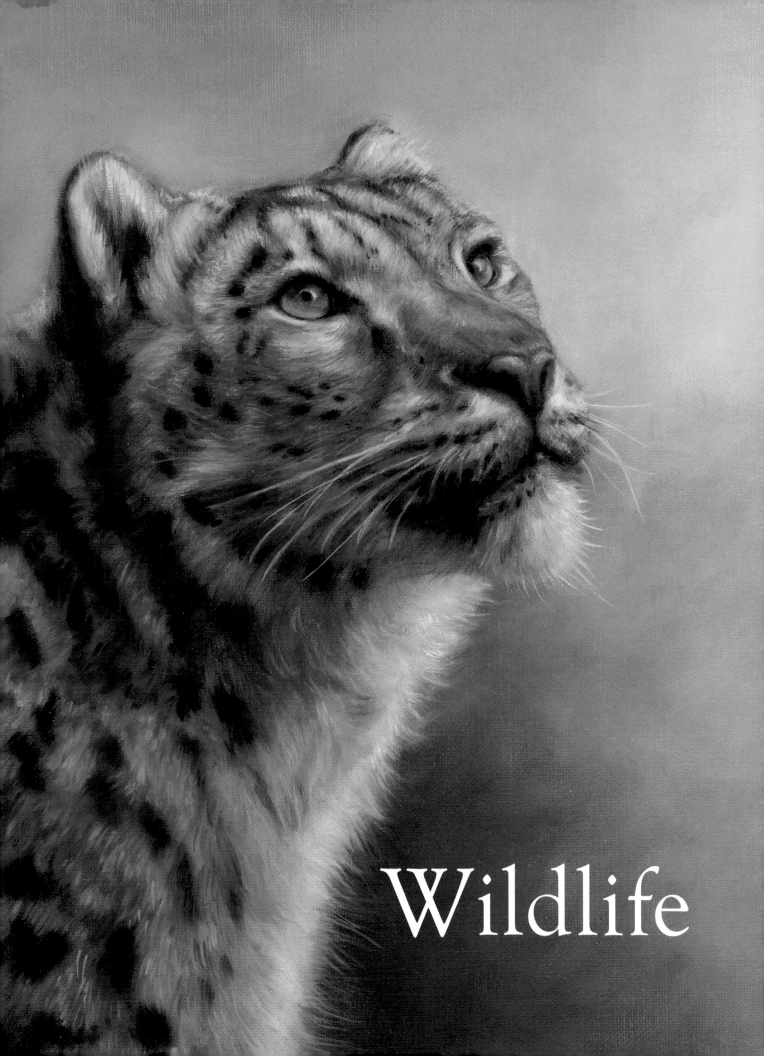

Wildlife

Inspiration

When I am travelling, I can often find inspiration for painting wild animals. I find experiences like shivering on a cold morning outside a Swiss log cabin, waiting to see a deer, ermine or Snow Grouse to scurry past, are necessary for me to connect with the subject. Whether it is birds on the foggy English moors, or monkeys in the Costa Rican rainforest, meeting the animals in their own living environment gives me inspiration and allows me to feel at one with nature.

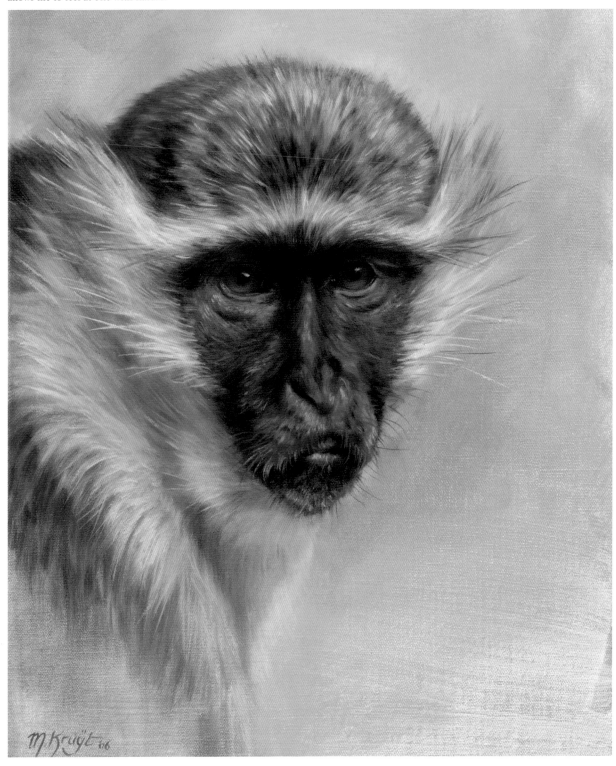

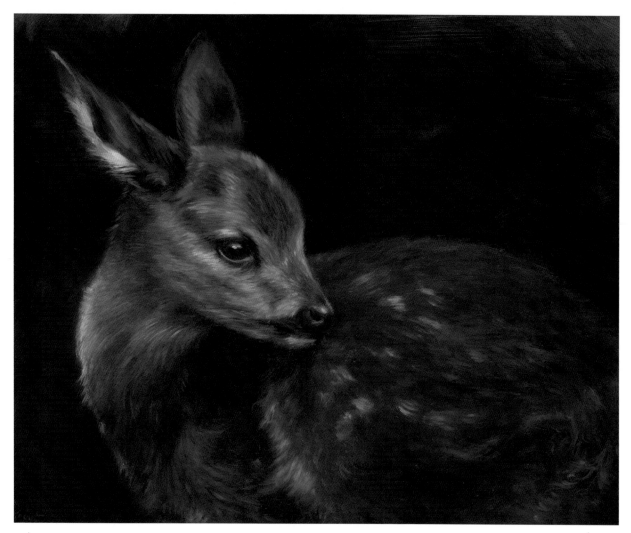

'Fawn', 24 x 18cm (9½ x 7in), oil on panel

I actually bottle-fed this fawn. She was still so very small, with such a fragile-looking body, and those large button eyes really moved me. My starting point in terms of light for the painting was quite Rembrandtesque in style: a dark area with a spot of light on the head of the animal. A fawn in all its vulnerability and tenderness.

Animals in zoos can also inspire me, but in a different way to those I see in the wild. Instead of the experience of an encounter, painting in zoos results in study paintings in which I can investigate anatomy and coats in detail. The range of animals in zoos in other countries is often very different from here. Zoos are useful to visit for animals that it is particularly difficult (or no longer possible) to spot in the wild, such as the Snow Leopard.

I also read up on the origin and way of life of the animal. With any reference work, when it comes to my paintings, I adjust the engorged 'zoo' bellies, and give birds back their flight feathers and their freedom again. Unfortunately, it is only through the medium of canvas and paint that I can place them in a natural environment.

‹ 'Green Monkey', 30 x 40cm (11¾ x 15¾in), oil on canvas

I met this monkey in a zoo in Brittany. He looked at me for a long time, and his gaze seemed to go right through me. This study is all about the beautiful coat, his intense look, and the depth in his eyes.

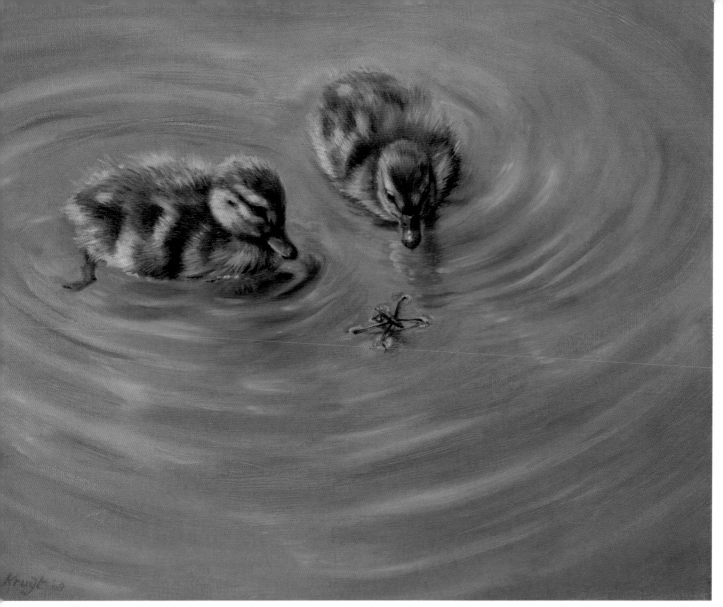

'Strange Meeting' - ducklings, 30 x 24cm (11¾ x 9½in), oil on canvas

This painting stood unfinished against the wall for a long time. A study of a single duckling in the ditch near my house became this painting of two ducklings. A year later, during the night, I suddenly got an idea of how to make the 'young innocence' of the ducklings all the more visible. How would they react to a meeting with another being that they had never seen before? When I added the water strider, the work was finally complete. The finished piece has taken on more meaning than just a realistic presentation of two swimming birds. It is as if they are wondering, 'what is that?'

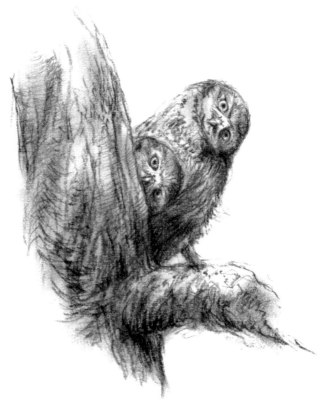

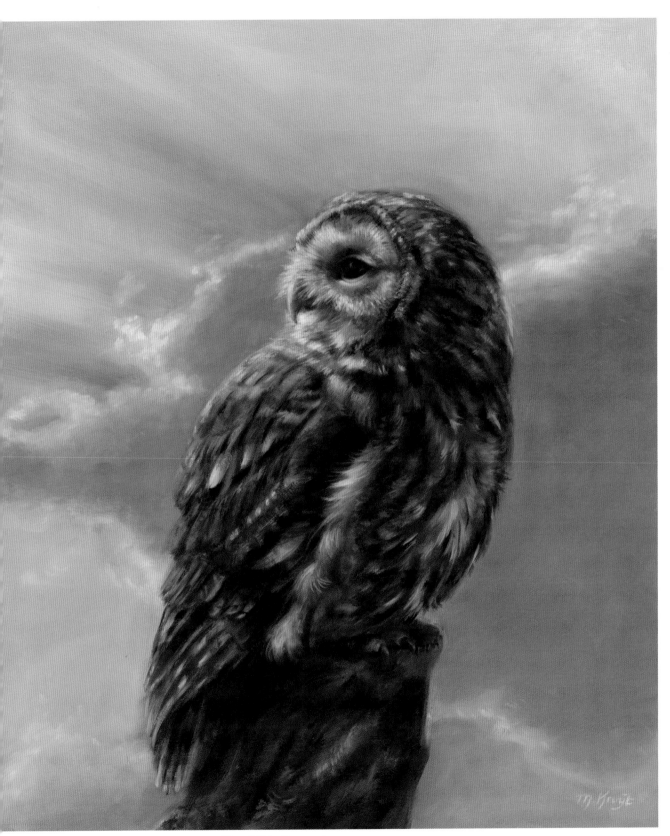

'Evening Glory' – Tawny Owl, 30 x 45cm (11¾ x 17¾in), oil on panel

I painted this Tawny Owl with a sunset in the background. As the light and the colours in the background are important for the atmosphere, I omitted the landscape and adopted a low viewpoint. To add life to the image, the wind is ruffling the feathers on its chest.

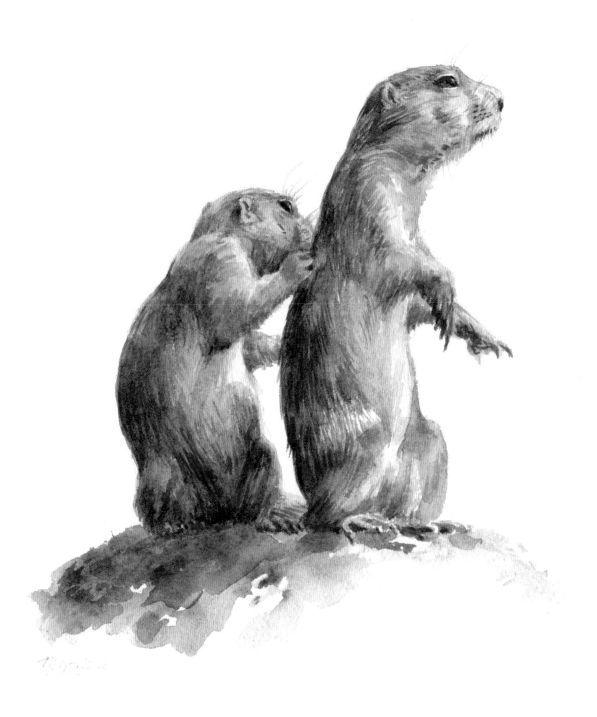

'Prairie Dogs', 15 x 15cm (6 x 6in), watercolour

'Morning Song' – Common Reed Bunting, 30 x 60cm (11¾ x 23½in), oil on canvas >

Dawn can be such a beautiful golden colour. I had already thought to do a painting that captured this glow effect, but I still had the location and the bird to figure out. After a walk through the nature reserve of the Oostvaardersplassen in the Netherlands, I was inspired to use these reeds as a basis – and which bird could possibly work better than a Reed Bunting? Their morning ritual is to sing their song, bathed in the golden morning light.

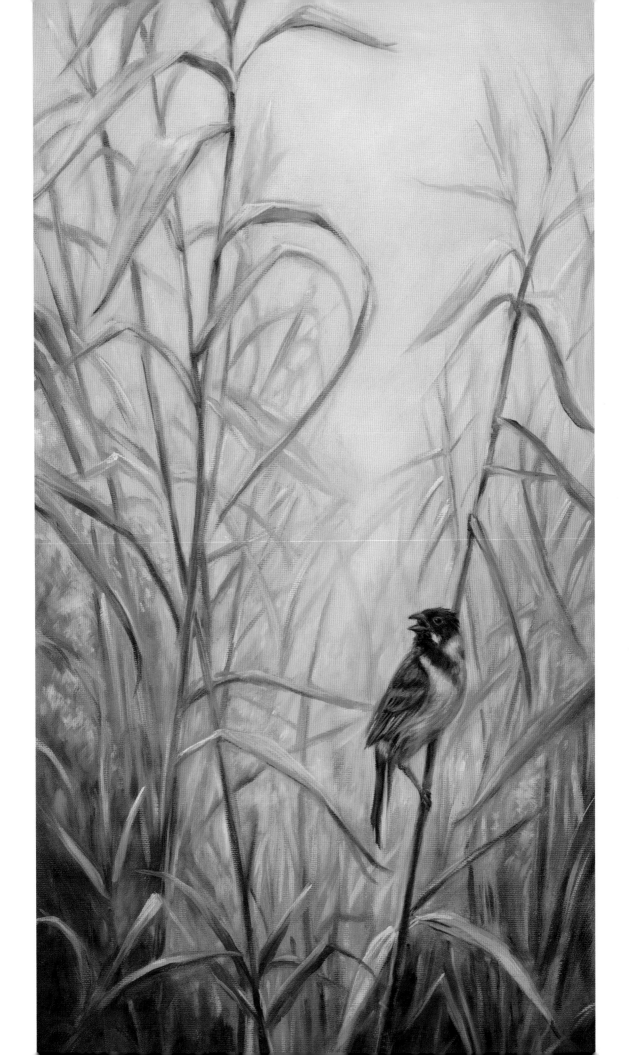

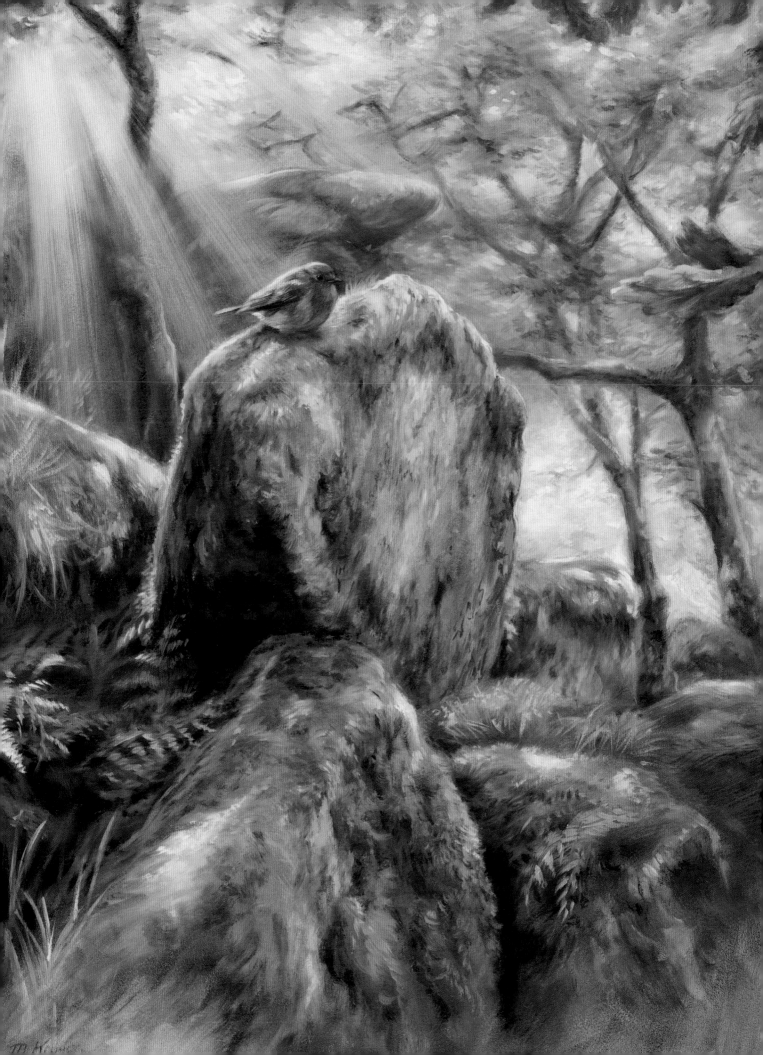

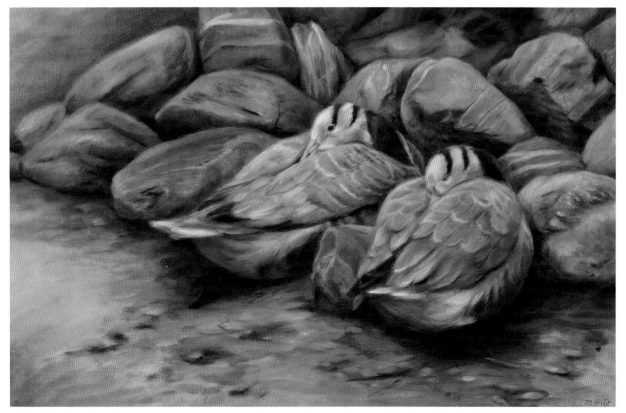

Using space and backgrounds

How do you place your animals in their environment?

The use of natural settings in a painting gives you the option of working with a 'scheme', such as a foreground and background, and objects that overlap the both of them, such as stones or branches. Just think of a diorama that you might have made as a child. It comes with the suggestion of space. In addition, through some extreme forms of lighting, such as backlighting or fog, you can add more space to a painting. By painting the background with less contrast than the foreground, you will get a spherical (atmospheric) perspective. It is the same as in real life: you can perceive more details in the foreground than in an object that is further away; and you can apply this principle to your painting.

'Hidden Feathers' – Bar-headed Geese, 60 x 40cm (23½ x 15¾in), oil on canvas

Geese survive in part because of their camouflage. I have chosen to paint these Bar-headed Geese in their natural surroundings where they almost to seem to disappear between the stones.

< 'Enchanted Woods' – Robin, 30 x 40cm (11¾ x 15¾in), oil on panel

For years, the mystical atmosphere of Wistman's Woods in England's Dartmoor has inspired me. The stones are overgrown by many species of moss, and the twisty oak trees have taken on the shapes of dragons and spirits of nature. The Robin, based on one from my own garden, looks friendly perched on one of the stones, probably happy because of all the flies and mosquitoes there, which I quite literally had to run away from.

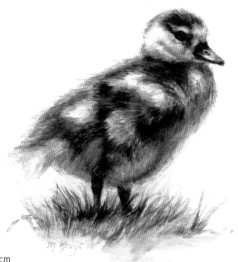

'Egyptian Goose', 15 x 13cm
(6 x 5in), watercolour

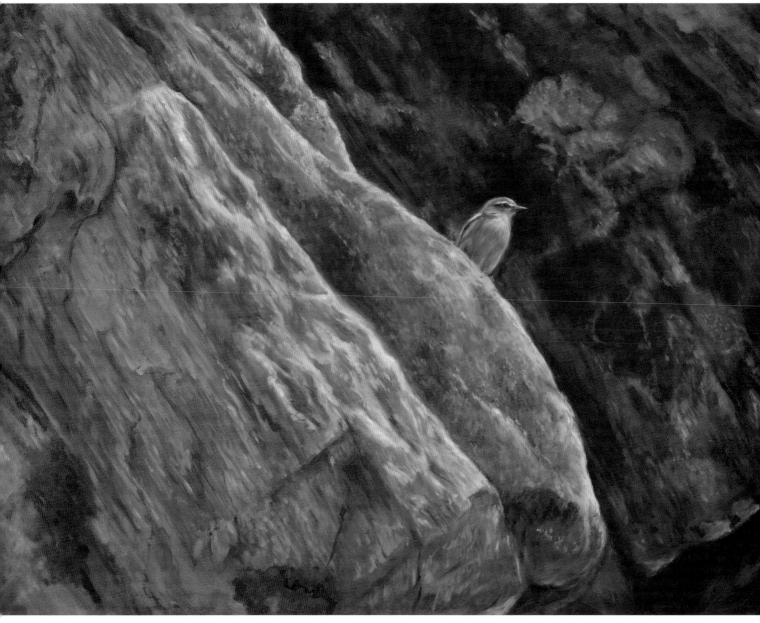

Texture

This painting is all about the texture and colours of stones. During a walking tour of Mont Blanc in the Alps, I saw these beautiful rocks, which I took as a starting point for this painting. The different mosses themselves appeared almost like rock paintings, with their own suggestion of mysticism; something that I like to use in my work. By adding a Wheatear, I was able to give the painting real depth – without the bird, the painting would have become abstract. There is now a tension between abstract and realism.

'On the Lookout' - Wheatear, 60 x 40cm (23½ x 15¾in), oil on panel

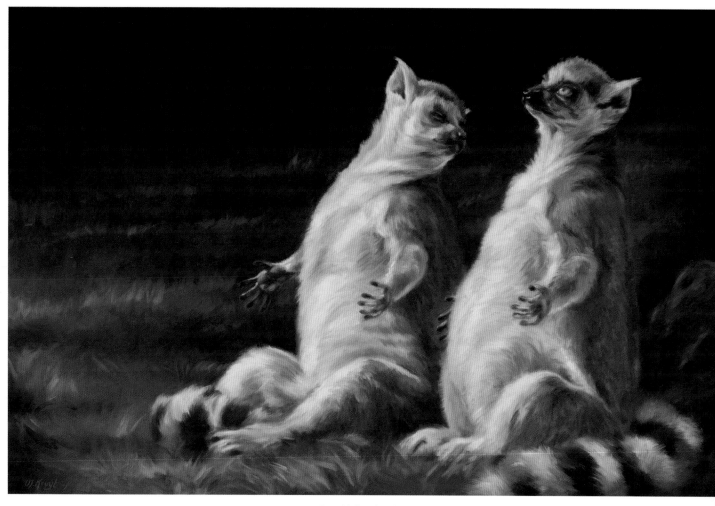

'Sunbathing' – Ring-tailed Lemurs, 60 x 40cm (23½ x 15¾in), oil on canvas

Combining landscape and animals

These heavily pregnant Ring-tailed Lemurs are sitting basking in the sun. In reality, these two are actually the same animal – I simply used different reference sketches to get the two poses. I darkened the background so that the lemurs stand out, which also makes the sun seem to shine more brightly. In addition to the image of two animals enjoying themselves, I wanted to add something special to the picture – interaction. I painted one looking at the other, as if she is saying, 'Wonderful, isn't it?' This creates a sense of dialogue.

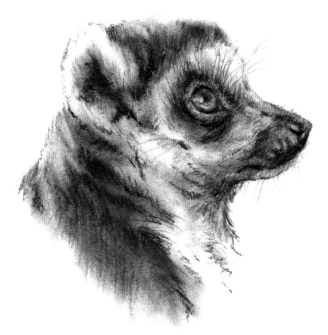

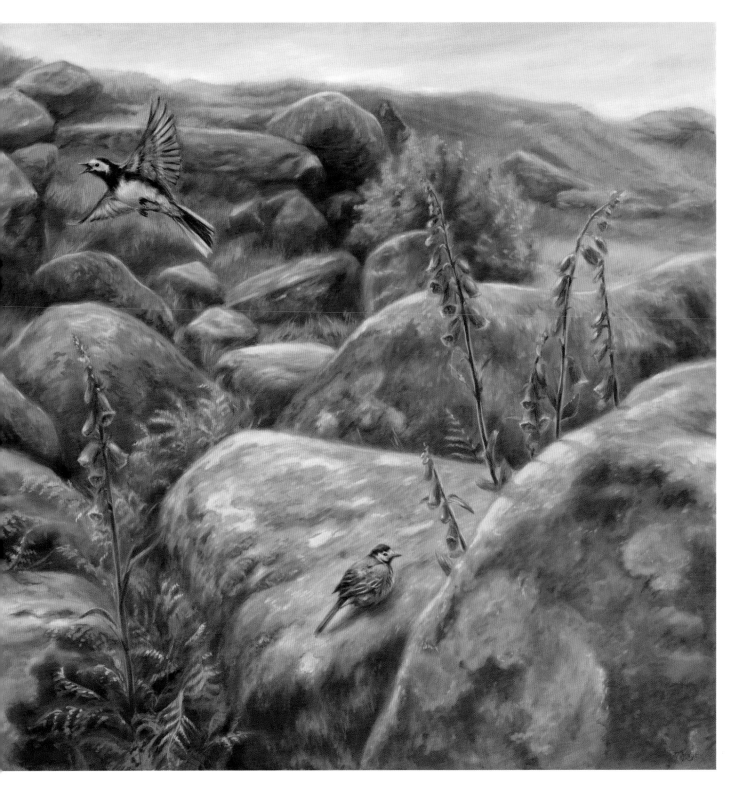

'Sunlit Foxgloves' - White Wagtail, 80 x 80cm (31½ x 31½ in), oil on canvas

The sun shines on the foxgloves growing among the rocks at Dartmoor, England – a feast for the eyes. A young Pied Wagtail is sitting in the sun, and its caring parent flies back and forth to it. In this painting, I have combined several different locations and images into one. For a realistic effect, the lighting on the bird and the natural surroundings need to match. If you are combining several elements, you also need to be careful about the size of the animal compared with its surroundings. A bird can seem too small next to a large flower if the proportions are not correct.

In order to achieve that, I completed various studies of the wagtail; how he walks, flies and moves.
This is a valuable addition to the painting process, because the knowledge gained of these characterful
movements helps capture the anatomy on canvas in a way that makes it seem as alive as possible.

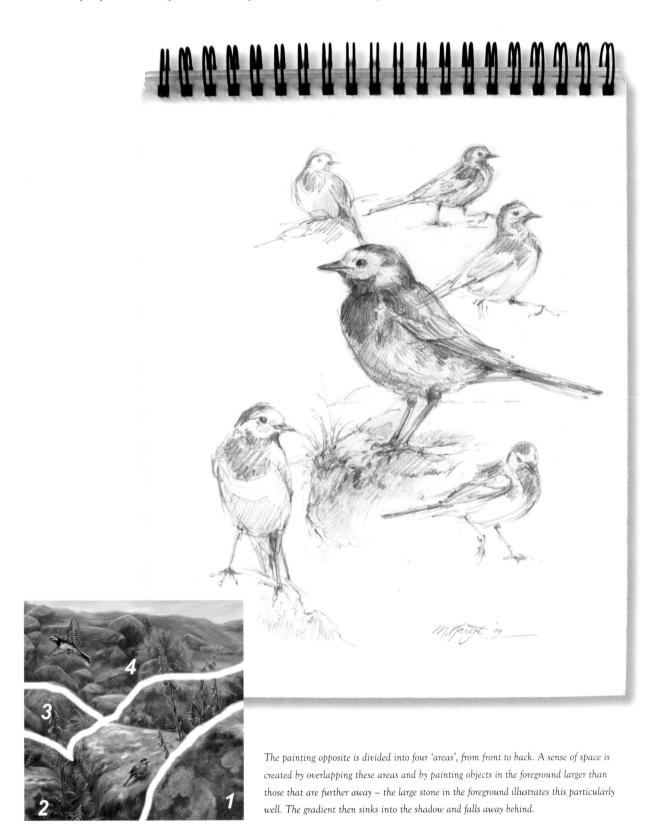

The painting opposite is divided into four 'areas', from front to back. A sense of space is created by overlapping these areas and by painting objects in the foreground larger than those that are further away – the large stone in the foreground illustrates this particularly well. The gradient then sinks into the shadow and falls away behind.

Anatomy, fur and feathers

Furs, scales and feathers are part of many wild animals' different survival methods. A thick coat will keep them warm in the winter, while feathers must be lightweight enough to be able to fly. The plumage of some birds are used as part of the mating ritual. It is also interesting to delve into the differences in feather and fur between males and females. In contrast to the human race, you will find that most of the grandeur and splendour is displayed by the male in most species.

There are of course many different types of furs and feathers in terms of stiffness, thickness, softness and pattern. They change seasonally and can be a subject of study in their own right. For example, a striped tiger that is lying half in the sun has so many different colours. In the same way, a black dog can appear to be brown when in sunlight.

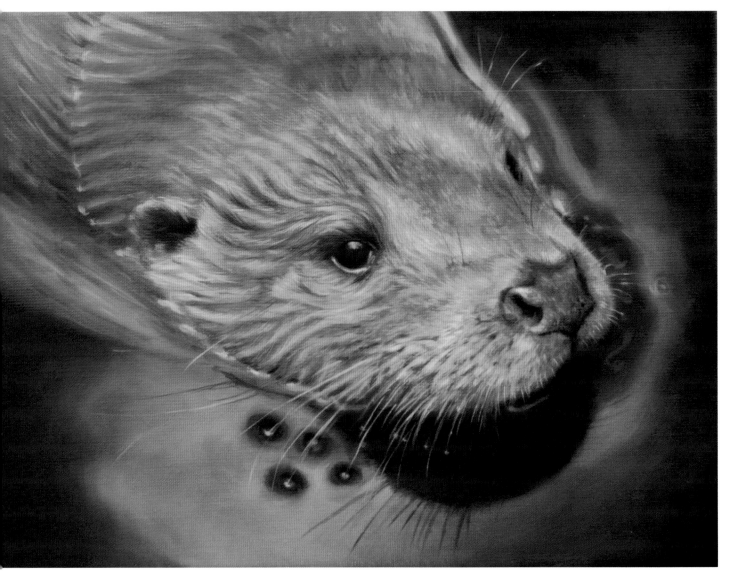

'European Otter', 40 x 30cm (15¾ x 11¾in), oil on canvas

This swimming otter's fur coat seems almost to be plaited, a result of the natural oils that waterproof the fur and allow the current to flow easily past the body. If the fur were to absorb the water and become heavy, then the otter would quite simply not survive. It is plain to see where the surface of the water has been broken, from the bright edges along the coat. It was the tension of the water's surface being punctured by the whiskers that prompted me to paint this otter.

'Pondering' – Brown Bear, 80 x 80cm
(31½ x 31½ in), oil on cloth

The coat of a bear is a good example of a coat
that combines long and short fur. The fur on its
body, like that on its cheeks and ears, is a little
longer, whereas the hair on its face is short.
I have painted the coat using big, wide, old
brushes, and a wet-in-wet technique. The only
place I used a softer, finer brush was for the
eyes. I regularly visit this bear, Mooky, in the
Amersfoort Zoo in the Netherlands where she
lives. She can be recognised by the slight tuft on
her cheek and her beautiful white nails.

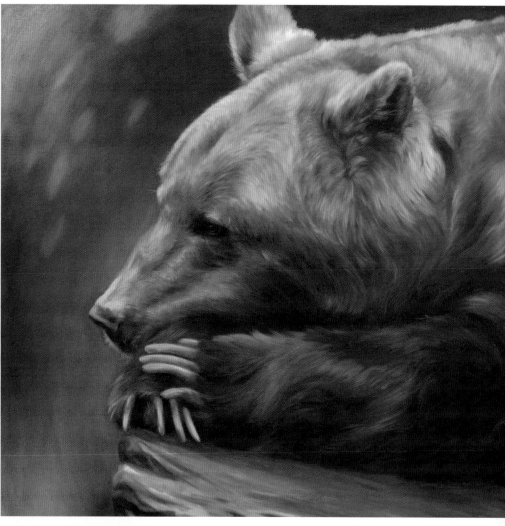

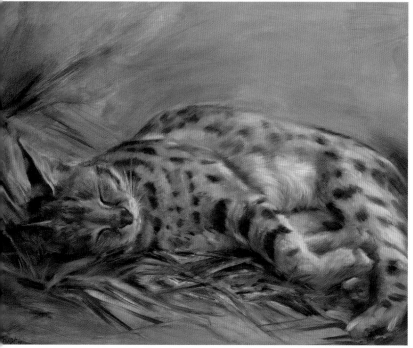

'Nap Time' – Serval, 30 x 24cm (11¾ x 9½in), oil on panel

The serval is much hunted for its beautiful coat of spots
and stripes. In this study, I have not created each dot to
perfection, but have concentrated on seeing what is
happening to the colour of the standard black spots in the
light. On the top of its stomach, there is more light falling,
so the dots there appear to be browner and lighter. In the
shade, as with his paws, the dots are darker.

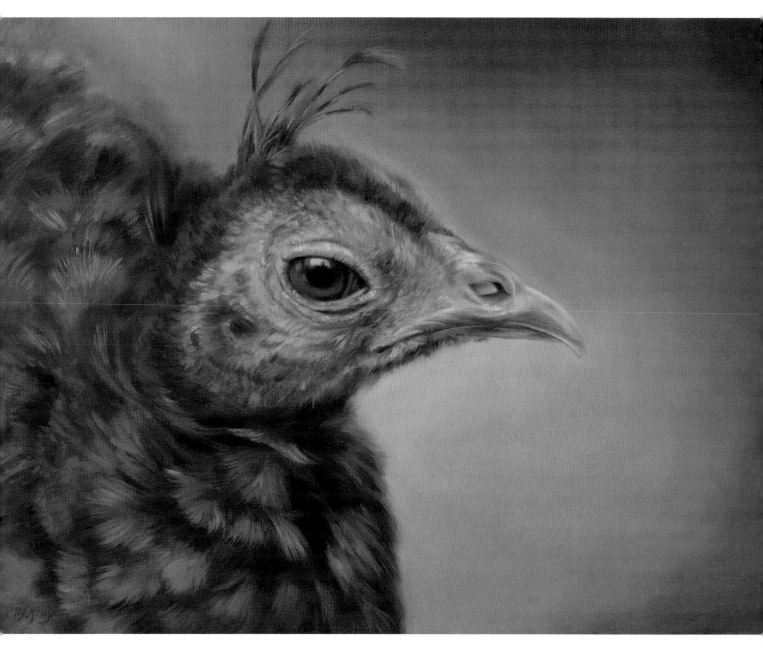

'Congo Peafowl' (female), 40 x 30cm (15¾ x 11¾in), oil on canvas

Here, there are three types of feathers: the typical glossy feathers of a peafowl on the back, the fan-like chest feathers, and the feather plume on the head. These are painted using a wet-in-wet technique, with old broken hog brushes, as described in the demonstration of the rabbit on pages 132–135. Thanks to the colour of the shadows, the sheen in the painting looks as if it is about to break free from the canvas.

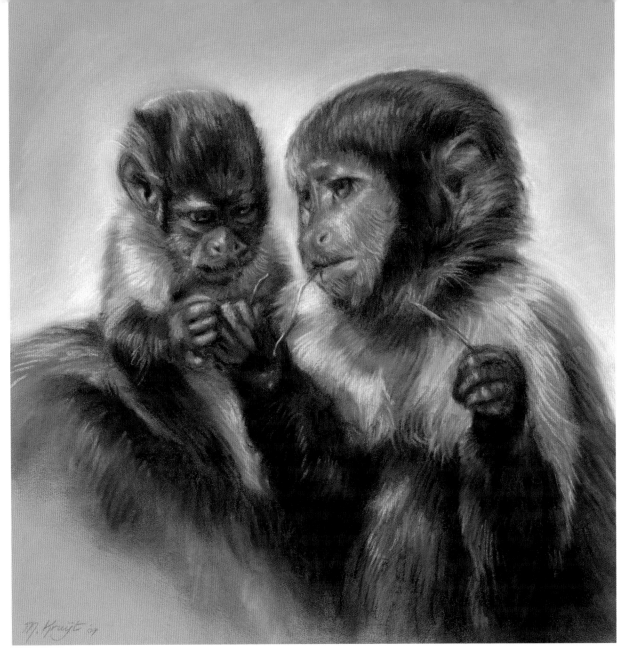

'Big Brother' – Golden-Bellied Capuchins, 30 x 30cm (11¾ x 11¾in), pastel on Colourfix

A young monkey is watching, mesmerised by the blade of grass held by his brother, who is steadfastly looking in the other direction. The playful behaviour of young animals is very fun to draw. You can clearly see how the eyes of the young monkey are closer to each other than in adult monkeys. In many animals (such as boars or deer), the young are better camouflaged, but the coats of these young monkeys are already quite similar to those they will wear as adults, which make them practically invisible in their natural environment.

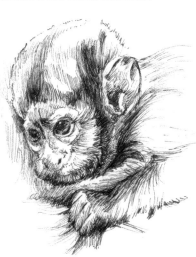

'Young Golden-Bellied Capuchin',
15 x 8cm (6 x 3¼in), ink

Drawing at the zoo and on your travels

If you draw at the zoo, you will always be the centre of attention. Whether young or old drawing remains a fascinating phenomenon. Curiosity will win out and most people will come to have a look. How does an artist manage that? What if the animal does not stay still? Many people think that it is only art students and 'real artists' who go and sit on a rickety stool between the

camels and penguins. It seems a scary thing to do. 'Imagine if you fail at it, just when people are watching'. So, you need to make up your mind now: suppose you do go and you make 'mistakes'... So what? You just carry on and the visitor will continue on their way. Everyone has to do it for the first time, so just do it!

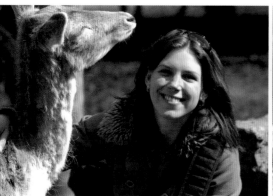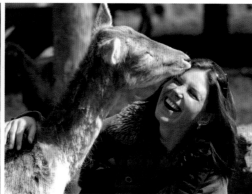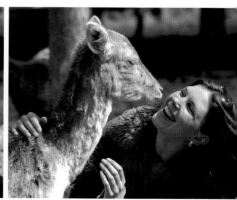

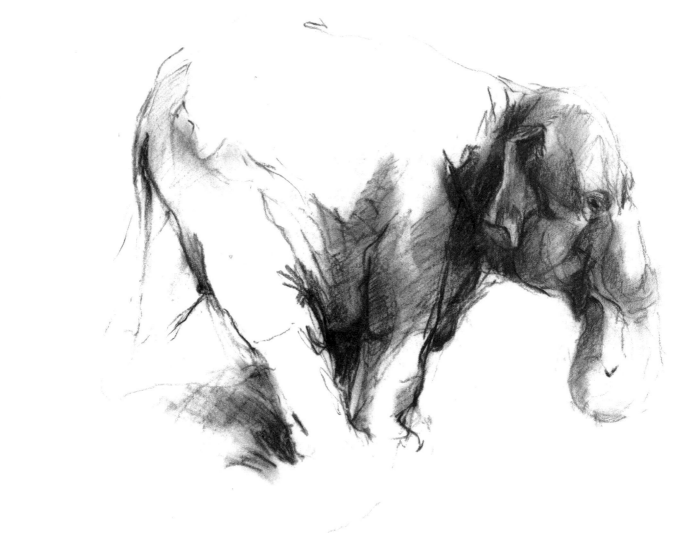

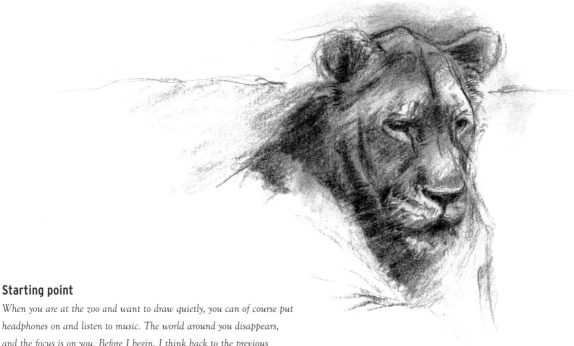

Starting point

When you are at the zoo and want to draw quietly, you can of course put headphones on and listen to music. The world around you disappears, and the focus is on you. Before I begin, I think back to the previous evening – what do I want, why do I want it, and how am I going to achieve it? What do I want to study? Should I go for more detailed drawings or sketches? Keep your goals small and simple. Over time I have learned to choose just a few starting points on each visit and to set a time limit. You need to see drawing as a process and have fun in 'just doing it'. You will naturally learn to observe and to practise remembering what you see. Just take a few sketching materials – charcoal and pencil, for example. Read some more about using materials and basic drawing techniques in the chapter 'On location' (see page 21).

Tip
Keep an eye on your stuff as people, especially children, can bump into things when they are watching curiously – Indian ink does not look good on the shoes of an enthusiastic onlooker. Close jars and store loose materials carefully. In addition, it is better to do any fixing at home as it can be very unhealthy for the animals.

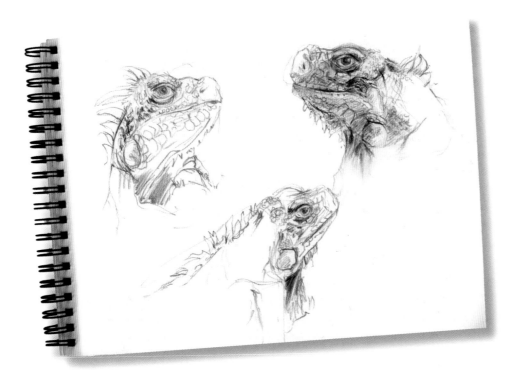

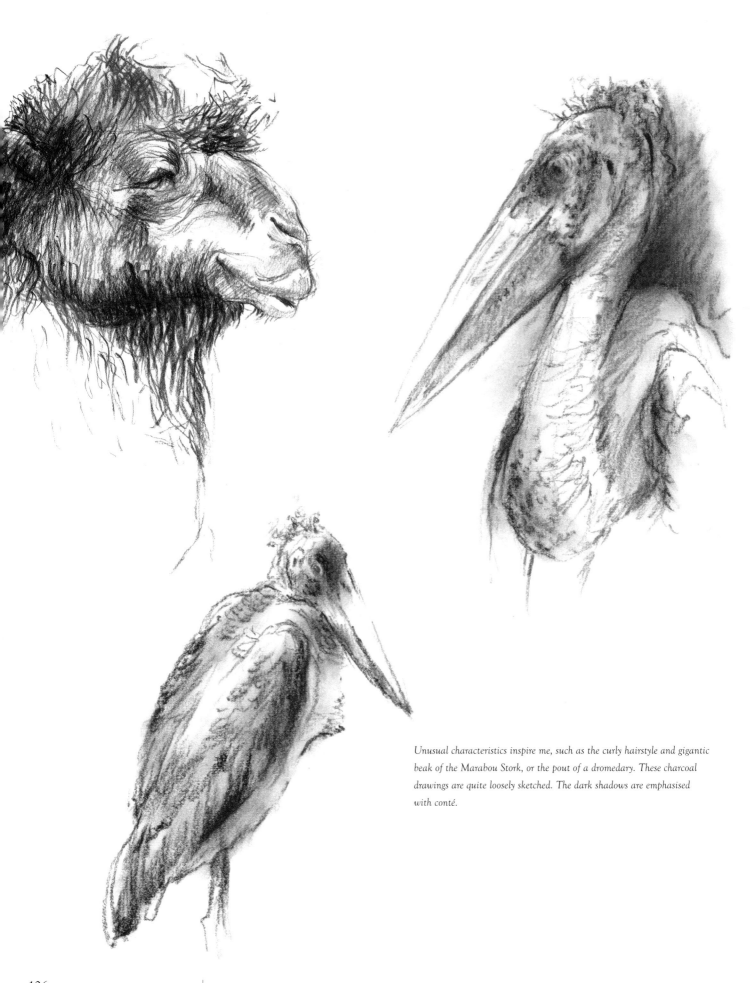

Unusual characteristics inspire me, such as the curly hairstyle and gigantic beak of the Marabou Stork, or the pout of a dromedary. These charcoal drawings are quite loosely sketched. The dark shadows are emphasised with conté.

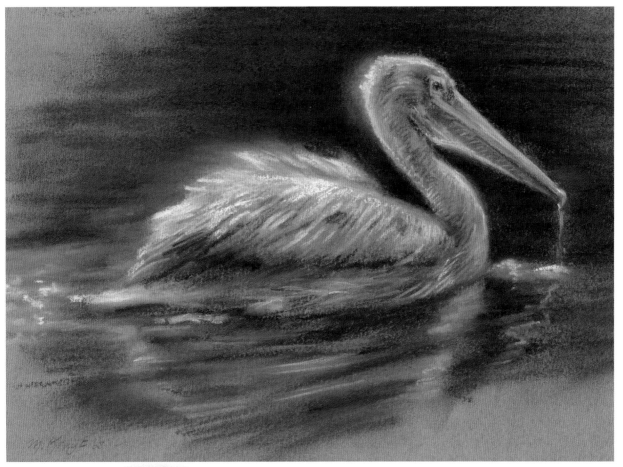

'Pelican', 20 x 15cm (7¾ x 6in), pastel on Mi-Teintes

Pelicans have a place in the sun. During their bathing ritual, I often see them strike beautiful poses. This pelican was going into darker water. The light from behind gave a beautiful softness and sheen to the feathers, and the light shone through the beak.

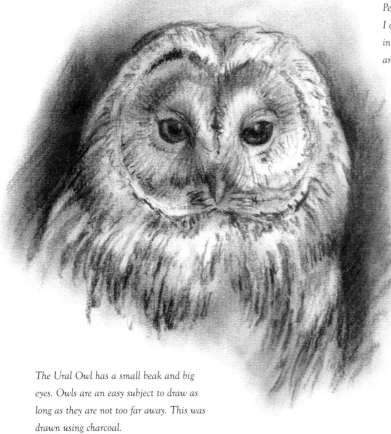

The Ural Owl has a small beak and big eyes. Owls are an easy subject to draw as long as they are not too far away. This was drawn using charcoal.

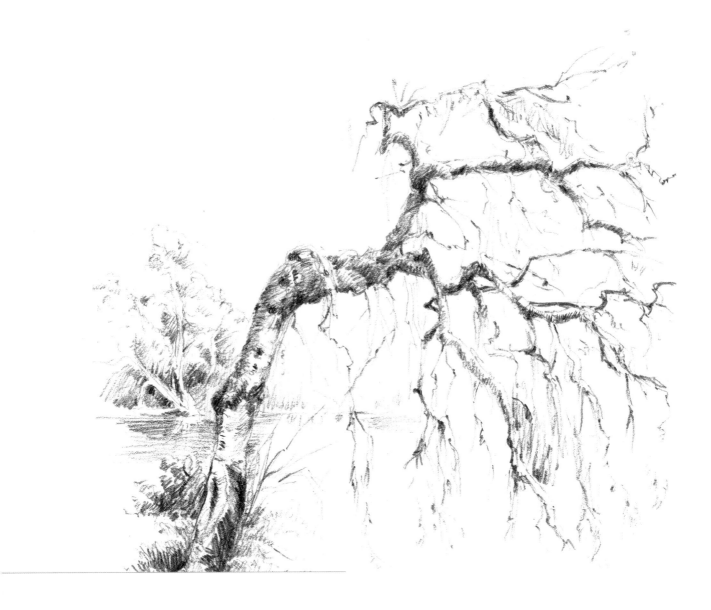

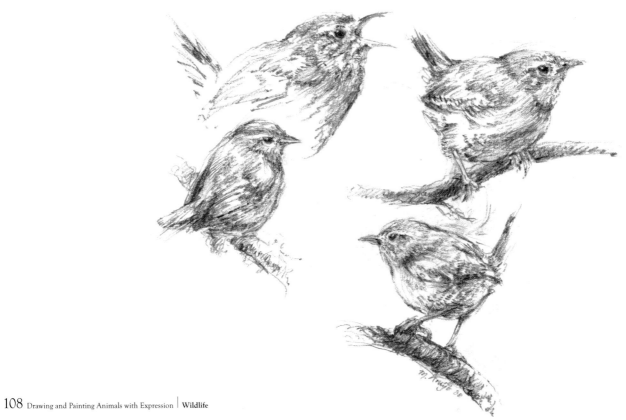

In addition to the animals, you can often find beautiful flora in the zoo, especially in the larger ones. These include simulations of complete virgin forest with flowers and shrubs, but wending along the paths you will also find beautiful trees, such as old oaks, beech, or even bonsai in the Japanese garden. These often attract sparrows, finches, robins and wrens within drawing distance as they come to take a look. The wrens and the birch tree shown on these pages are drawn in pencil.

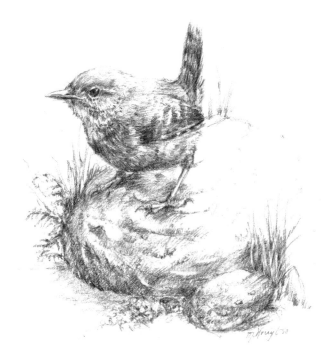

'Lambs', 26 x 15cm (10¼ x 6in), pastel on velour paper

In the petting zoo in the spring, you can often see the lambs and kid goats. You do have to pay attention though, because they like to nibble on your paper and your backpack! I have had to throw away some drawings because a small kid that was by my shoulder climbed astride me and landed on the drawing. I do not use pastels near animals because of the pigment dust, and so only use them from a safe distance.

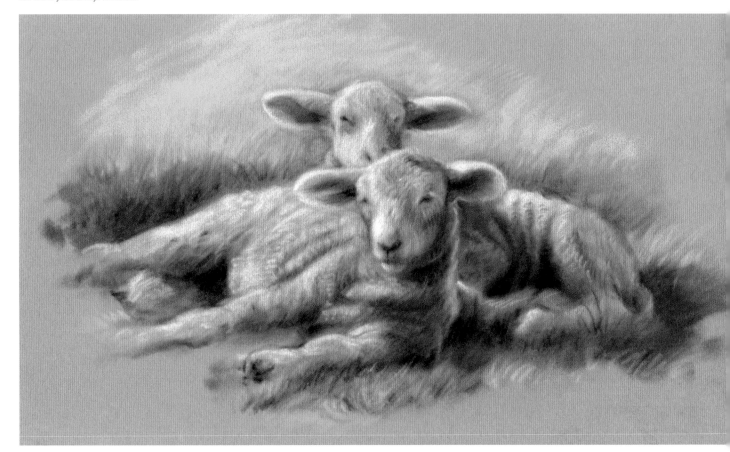

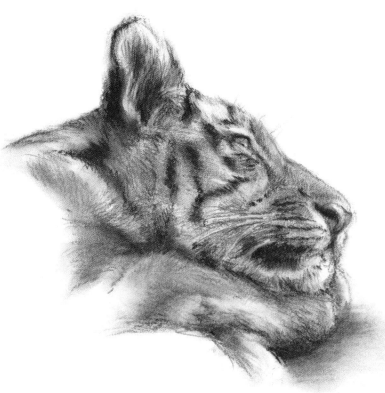

Begin drawing animals with lots of feather and fur patterns, like peacocks or giraffes, when you are confident that you no longer get lost with drawing stripes and plumage. First of all draw the shape of the heads, and then the patterns.

If colours or stripes in the coat distract you from adding the shadows clearly, then practise them first in charcoal. As you are working in grey, punctuate it with the visual distraction of colour and textures, because essentially you are drawing only shadows.

Some quiet animals to draw are reptiles (you can also sit with them and stay nice and warm in winter), as well as insects, butterflies and nocturnal animals.

Fish and Ring-tailed Lemurs are suitable for making quick sketches of movement.

Reflect on your work at the end of the day: what were the positives and negatives? What would you do differently next time? What gave you satisfaction? Reward yourself with a pat on the back – it was not that bad after all!

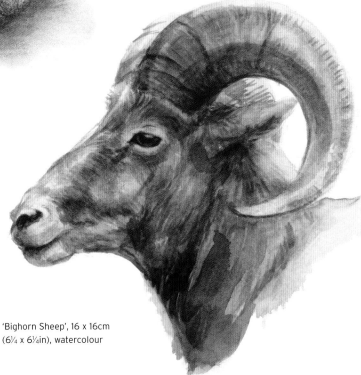

'Bighorn Sheep', 16 x 16cm
(6¼ x 6¼in), watercolour

'Detail of Tiger Studies', 60 x 50cm
(23½ x 19¾in), charcoal

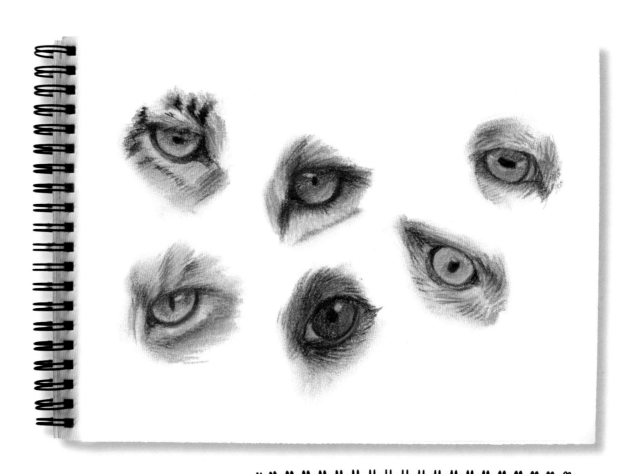

Once a day, draw eyes, ears, beaks and horns in isolation. On the right, you see the ears of a rabbit, tiger, rhinoceros, chimpanzee, caracal, elephant and horse. In the drawing above, you can see the differences in irises and pupils of a leopard, lion, sheep, domestic cat, Jack Russell, and a hawk. Did you know that a sheep has a rectangular pupil and that big cats have round pupils?

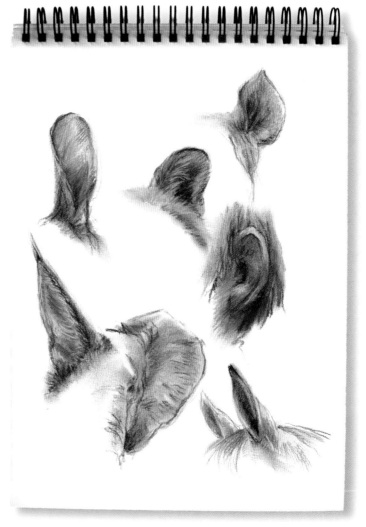

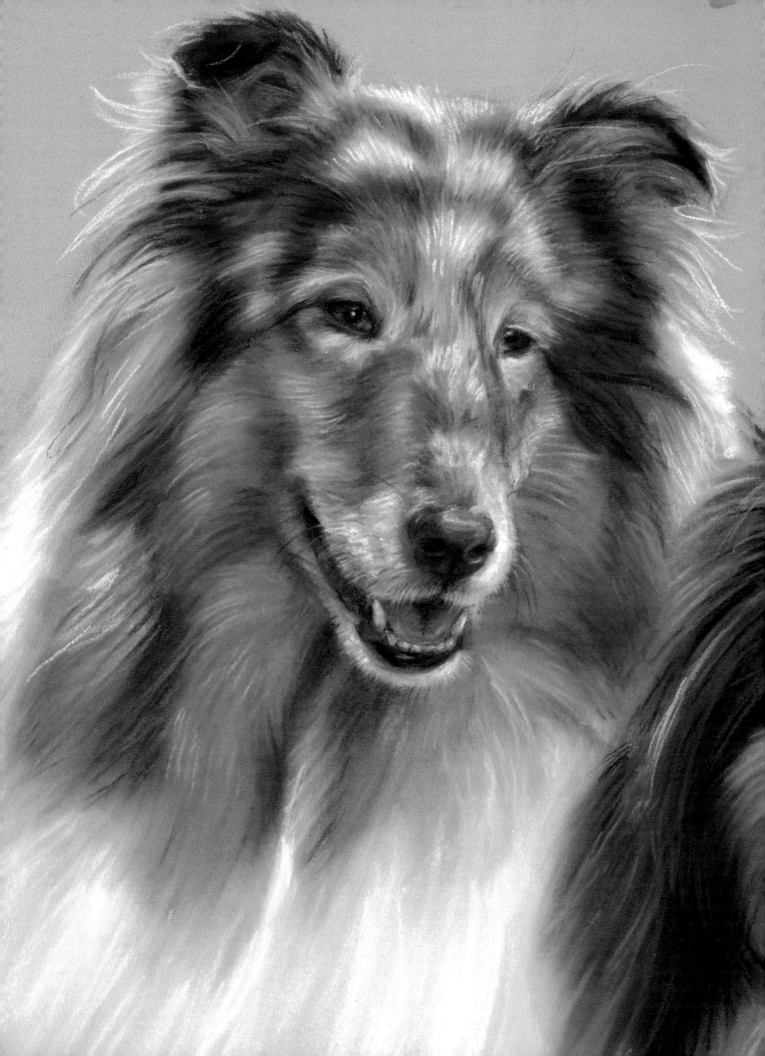

Demonstrations

BORZOI IN OILS

Borzoi dogs have an extremely long nose in comparison with other dogs. The fur varies from short on the muzzle, to long at the neck and ears. In this demonstration, I will show you how you can paint a white coat in oil paints and how you can catch the light.

Materials

Oil paints (see colour palette on page 17)
HB pencil
Putty eraser
Prepared panel 35 x 30cm (13¾ x 11¾in)
Quick-drying medium
Synthetic brushes: size 8 flat, size 12 flat, size 1 round
Hog hair brush: size 1 round

Step 1

I draw the design with an HB pencil. The ratios are the most important thing at this stage. The nose is at the same height as the leg. I also add in the contour of the ears and the spots in the coat. I make the pencil lines lighter using a kneaded eraser, so that they don't mix with the oil paint. It's also possible to do the master drawing in acrylic. This fixes the pencil lines.

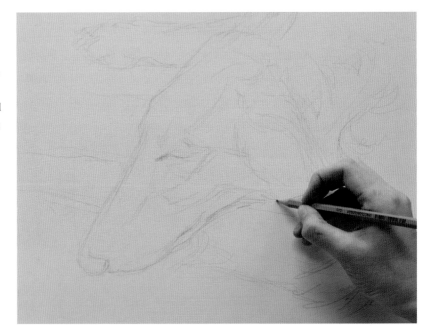

Step 2

Because I want to paint this painting in one go, I am going to use an opaque wet-in-wet technique. The layers must not dry in the interim. Working on each compositional area in turn, I paint all the shadows in a grey colour, diluted with a quick-drying medium. The lighter areas are in a light grey colour. The light is falling from above on to the dog, so the coat is lighter on top of the head and the legs.

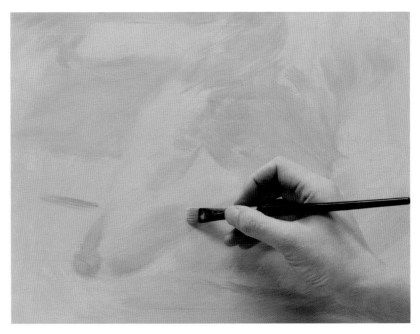

Step 3

In this close-up, you can see how I used a hog hair brush and a wet-in-wet technique to shade the shadows in a bluish-grey in the direction of the fur. This quickly gives it all the effect of a smooth coat. The light parts are thus missed out, in order to avoid mixing the colours too much. With a dark brown, I paint the eye area and muzzle.

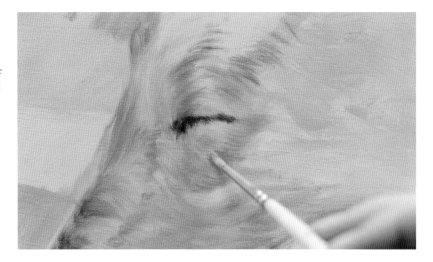

Using white, I add highlights into the wet paint. To transition between the colours, I use a dry, clean, flat brush. I build up the perspective by first painting the shadows and then the highlights, which I allow to come together and blend, mixing them on the canvas.

Step 4

With a wide, flat brush, I loosely paint the rest of the dog's head in the same way as in the previous steps. With some white, I add all the highlights that are on the top of the head. I paint the darker coat using a mixture of Vandyke brown and ultramarine blue, with a touch of quinacridone red, instead of black.

Step 5

Next, I paint the legs and the surrounding area. If, as a beginner, you cannot distinguish the shadows very well, then try working simply from 'three tones'. Here you can see a dark shadow under the leg, and a lighter shade along the toes, while the upper part of the leg is the lightest. This can be applied to each technique. After a while, you will discover the in-between tones without realising it.

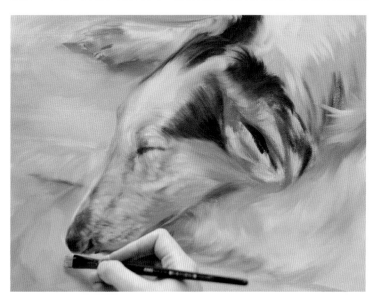

Step 6

Upon reflection, I found the muzzle of the Borzoi to be too short, so at this stage I corrected the length then paint the nose again. This is not actually too much work, because the oil paint remains wet for a long time. Using the white again, I once more add the hairs to the top of the muzzle. Next, I paint the ears and coat with a larger brush.

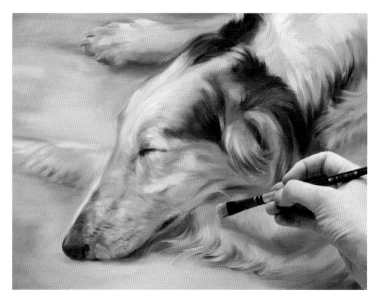

Tip

When painting white fur, you should choose the colour of the shadows in advance. It is only where direct light falls on the coat that the colour appears pure white, while the rest of the coat consists of numerous different shades. You can work with different shades of colours; for example, brown is a warm shade. Here, I chose cool blue-grey shadows.

Step 7

With a small brush I work out the details. I add dark strokes at the ears, then light hairs at the muzzle, on the cheeks and along the legs. With a wide, flat, clean brush I smudge the transitions to soften the coat. I then paint the surroundings somewhat paler, using a light blue colour. The same colour is then used again in the leg area and on the muzzle. Finally, I look at the whole painting to see where the brightest light falls. I add a touch of lemon yellow to the white, so that the white looks brighter. In this way, I will accentuate the edge along the nose, the sheen on the head and in the neck.

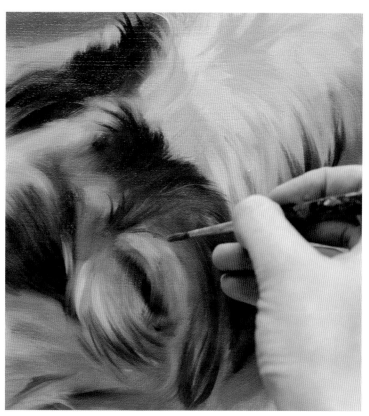

'Borzoi', 35 x 30cm (13¾ x 11¾in), oil on panel

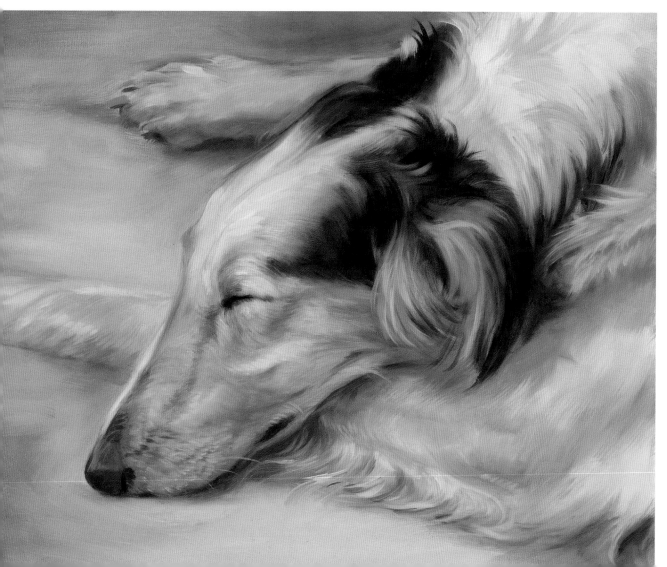

COLLIES IN PASTELS

Collies have a beautiful long, soft coat. The hairs on the muzzle, by contrast, are short. In this demonstration I will show you how you can draw this softness and the varying lengths in pastel. To make the details visible, we will focus on the collie on the left. Follow the same steps for the second collie.

Materials

H pencil
Putty eraser
Pastel pencils (see colour palette on page 15) and white chalk
Pastel paper 50 x 60cm (19½ x 23¾in), soft rose

Step 1

With an H pencil, I begin by drawing the collie's head. Using exploratory lines, I sketch out the eyes, around which I capture the shape of the head. At this stage, I note whether the eyes are at the same height, and I look for parallel lines, such as the ears and the nose, which run in the same direction. In this case, the eyes are in the middle of the head. The ratio between the forehead and the muzzle is sometimes the same length. By looking for corresponding distances in the head while sketching, you turn this into a discovery stage.

Tip

Only use white chalk for the highlights, in the places where the most light falls. That way, you are able to catch the beautiful sheen on the coat and the wet nose.

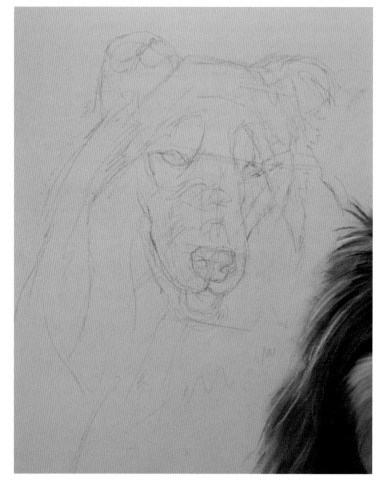

Step 2

Using ochre, dark grey and light grey pastel pencil, I shade in the coat over the entire head area. With my finger, I wipe over the transitions so that they are soft, just like the real coat of the collie. In this close-up, you can clearly see how I have shaded light blue over the dark grey.

Step 3

I then build up the rest of the head using two layers of pastel: firstly the slightly darker colours, over which the lighter colours are superimposed. This ensures that you get the effect of shadow between the hairs, and gives you quick results. I do not press hard with the pastel pencils, because I do not want to saturate the paper and I still want to create an additional layer with more details. By starting to draw using only three colours (in this case, ochre, dark grey and light grey), I can keep observing the direction of the coat. After drawing in the second layer with the lighter colours, I then observe further to see upon which areas the light falls. This build-up effect is used for all pastel drawings of animals.

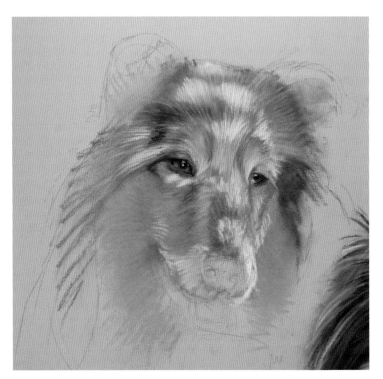

Step 4

I then continue with the neck ruff. Over the ochre, I now draw in the sharper hairs using a light yellow pastel pencil and warm orange. As the muzzle has more hair, these become shorter. I no longer wipe over this because I want to retain the sharpness.

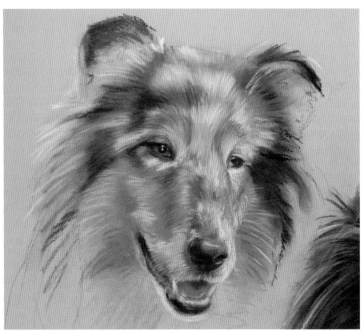

Eyes

It might seem like a lot of work, but I very quickly establish the eyes in three colours. I always start with the eye rim, in a dark brown. Then I give the entire eye a warm brown tone, into which I draw the pupil in black. Finally, I use a white chalk to add the highlight to the eye, then use light yellow to draw any dashes into the brown iris, which creates the vitreous appearance of the eye. There is always light on the lower eyelid. The way to do this is to draw a grey stripe over the dark brown of the rim of the eye.

Step 5

I now work more details into the entire portrait.
To make the appearance of the coat softer, you can
soften all of the outer contours. If you look at the
ear, you can see how the edges are lighter and how
I have smudged them using my fingers, before
adding white and orange strokes over it all.

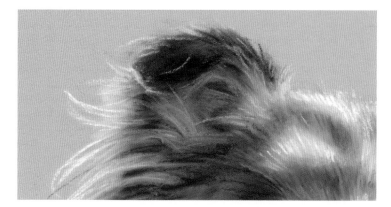

The coat

Here you see how I have used the 'three tones': an
underneath layer in brown (right) and grey (left), and
over this, the lighter colours of orange (right) and
light grey/blue (left). As a third layer, I have added
light yellow (right) and white (left) as highlights.

The muzzle

Teeth can quickly appear unnatural and too clean if you draw them in white. That is why I first of all draw
them in light brown, mixed with light grey. I chose a dark brown for the spaces between the teeth and then,
for the shine, a white colour. I mix red and grey together to achieve the colour of the tongue and I chose a
light pink for the sheen. I am then ready to work on the details. I like doing the strokes along the lips and
the whiskers, and so I save them until the end. Finally, I view the entire piece and I make sure the highlights
are correct. I follow the same procedure for the second dog.

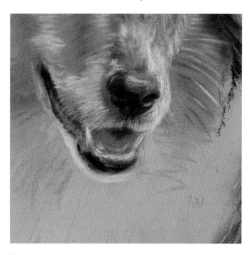
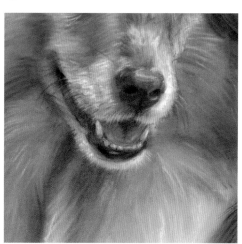

Tip
The shape of a dog's nose is quite complex. To simplify it, think of it as an oval
containing two circles. This basic shape is easier to convert into three-
dimensional forms, which can then be used to make the outlines rounder.

The nose

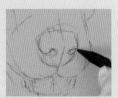 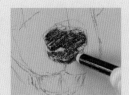 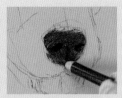 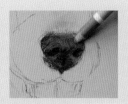

Step 1

With a pencil, I draw the nose. I take care over the proportions, because the muzzle is rotated slightly.

Step 2:

I completely fill in the nose area using a dark brown and a dark grey.

Step 3:

With black, I draw the openings of the nose and the vertical line on the nose. I then blend these colours into each other.

Step 4

The top of a dog's nose is light, because it is flat. I draw this in a light grey.

Step 5:

A dash of white, light grey and light blue give the impression of the shininess of a wet nose.

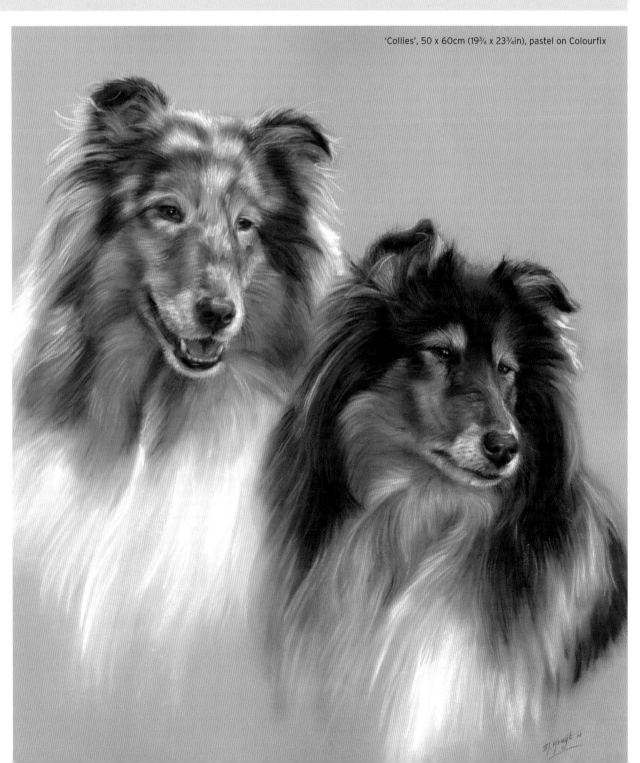

'Collies', 50 x 60cm (19¾ x 23¾in), pastel on Colourfix

MAINE COON IN WATERCOLOURS

There are a number of steps to follow when painting a portrait in watercolour. Always remember to work from light to dark, protect the areas you want to remain white, and feel free to use a piece of kitchen paper as a tool for lightening areas or for blending. You should also allow the paint to quietly take its own course. If you try to control watercolour painting, it can be at the expense of spontaneity. Paint can create some very beautiful effects by itself.

Materials

HB pencil
Putty eraser
Watercolour paints (see colour palette on page 19)
Watercolour paper 40 x 50cm (15¾ x 19½in), stretched on a board
Masking fluid

 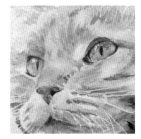 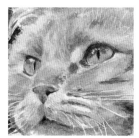 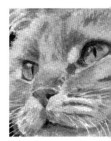

Step 1

Once the paper is dry from being stretched, I start the sketch using an HB pencil. This is done very lightly, because the watercolour will remain transparent. After that I draw in the whiskers using masking fluid so they will remain white, because the paint will be repelled. This allows me to quietly paint away using larger brushes, since I know I will not end up painting something accidentally. I build up from light to dark. Here, I use ochre as a basic tone. Using a wet-in-wet technique, I add a slightly darker brown to retain the characteristic of a flowing watercolour. I keep the white of the neck ruff by using masking fluid.

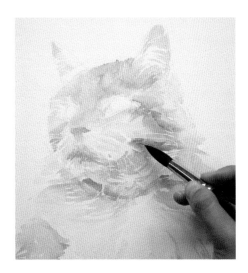

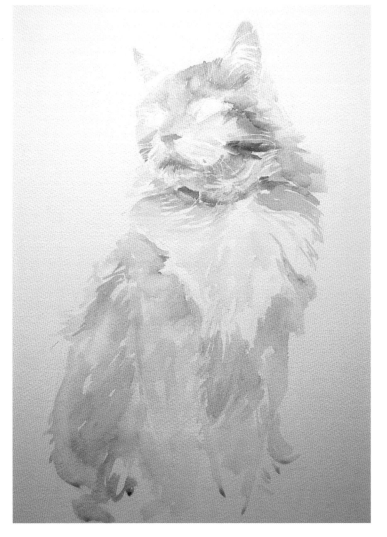

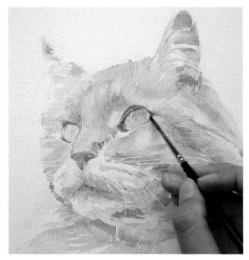

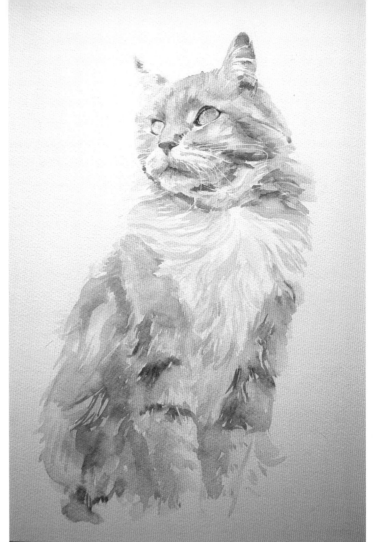

Step 2

At this stage I use a darker tone to paint the contour of the eyes and make the body more three-dimensional. I keep painting over the entire animal, so that the posture remains spontaneous. I do not just focus on the head. For the shadows in the white neck ruff, I use diluted brown shades, mixed with dark blue. I do not use black in my watercolours, because it is dull and drab as it mixes.

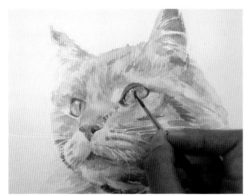

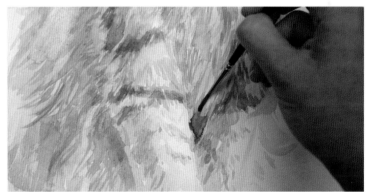

Step 3

I then paint the second layer of the eyes. I do not just apply the colour all in one go, but instead gradually develop the eyes using a wet-in-wet technique. First of all, I paint the pupil in a light brown colour to see if the vertical direction is correct. I protect the bright, white spots. For every stage, I choose an increasingly thin brush. It is important to continue to pay attention to the direction of the fur, and to paint the hairs accordingly. I allow the ochre colour that I painted on in step 1 to come through. That way, the coverage of the watercolour stays bright and varied.

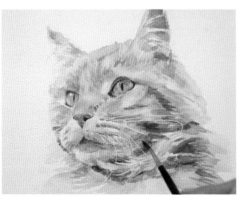

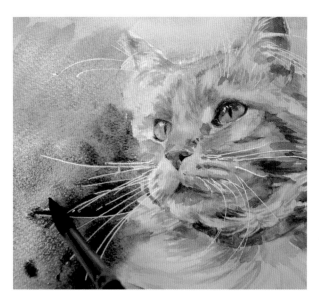

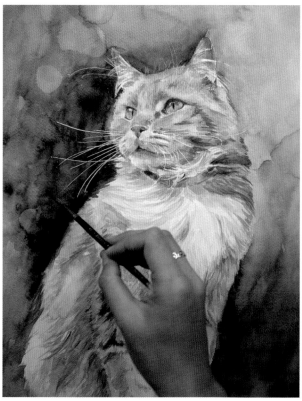

Step 4

Halfway through the portrait, I add the background. This visually modifies the contrast of the whole work, so I do not wait too long before I do it. I firstly use a thin brush to go around the edge of the coat. I avoid dry edges by blotting it with kitchen paper. I then paint the entire background with a broader brush.

Step 5

I then continue developing the coat by adding details. After drying the watercolour, I wipe off the masking fluid. I paint the edges a little, so that most of the reflective white disappears. I work on the eyes in dark brown, so that I can capture the look and character. I do the least amount of work on the eyes at this stage. The more you practise, the more accurate you will become. You should try to achieve clear and transparent eyes when working in watercolour. As soon as I get the impression that the contrasts are well balanced and I have captured the right look, then the work is complete.

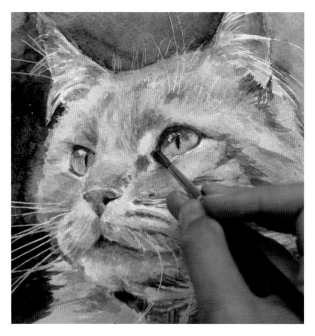

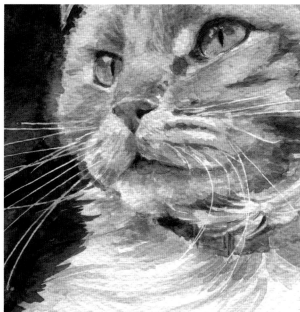

Tip

When using watercolours, you can simply avoid the area for the white whiskers, painting around them and letting the clean paper suggest the whiskers. For extensive or plain backgrounds this can be tricky. Another method you could use is masking fluid. After removing the fluid, you will have some very sharp edges, which some watercolour artists dislike. The white parts seem to break away from the rest. By softening these edges with a clean, wet brush you can blend them in and then gently paint over them.

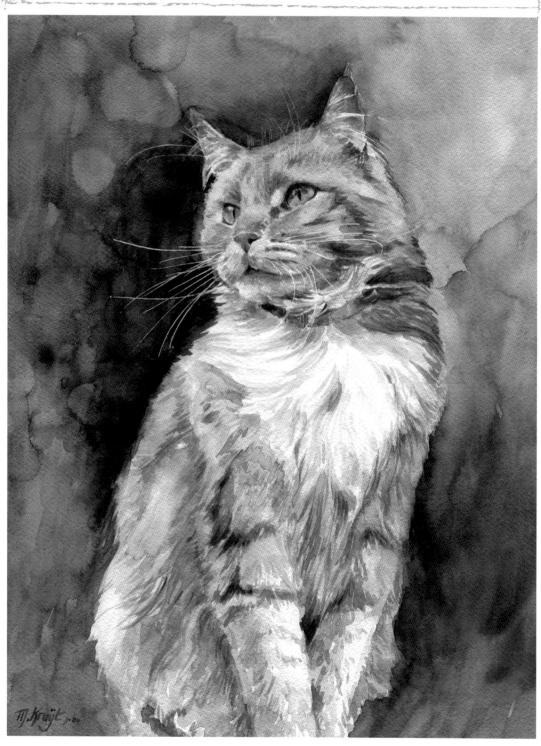

'Red Maine Coon', 40 x 50cm (15¾ x 19¾in), watercolour

NORWEGIAN FOREST CAT IN PASTELS

The inspiration for this beautiful Norwegian Forest Cat was the stunning coat and the classic gentle pose. My approach to this work was that of a portrait, so the environment is not that important. What I wanted was to capture a stare, as if the animal was looking right through you. The playful strokes of the ears, nose and eyebrows are a nice bonus while drawing. I also wanted to portray this warm character in colours that were equally warm. I decided in advance which colours I was going to use. Her coat is not just brown with white; there are several warm brown tones and ochre on the light side, and light blue and various greys on the 'cold', darker side.

Materials

HB pencil
Putty eraser
Pastel pencils (see colour palette on page 15)
White chalk pastel
Colourfix paper 30 x 40cm (11¾ x 15¾in), soft umber

Step 1

I carefully sketch the Norwegian Forest Cat on the paper using pencil. The positioning lines for the eyes and ears run in parallel. For this stage, all ratios should be accurate. At this point, then, it is better to take your time, so that you can prevent the need for corrections in later stages. Using long lines, I check whether the eyes are the same height and the ears are in correct proportion to the head. If you draw a vertical line that starts from the innermost point of the ear, from the top of the head downwards, you will see that, in almost all cats, this opens out onto the middle of the eye. Once the cat was in the correct proportions, I used a kneaded eraser to dab over the lines I had drawn so that they became lighter. That means that I can prevent the graphite of the pencil from interfering with the light pastel colours in later stages. Lightly fixing it is also an option.

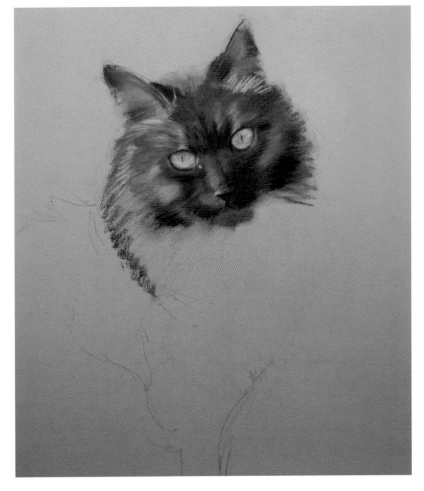

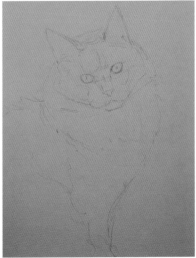

Step 2

With a dark brown pastel pencil I roughly fill in the entire head area, then shade within it using a black and light grey pastel. From the beginning, I made sure to shade the fur in the right direction. To simplify the process, you can build it up by returning to using three tones: a midtone (brown), the darkest shade (black, shadow) and the lightest shade (light grey). If these three are present, then you will have already captured a three-dimensional quality.

Close-up step 2

I often draw the eyes first, because the positioning and the gaze are crucial for a good likeness (see demonstration on eyes on page 128). After applying the three colour coats, I wipe over the colours with my finger, carefully blending them into one another. This gives immediate results. The coat and head are three-dimensional, because the lightest and darkest colours have already been identified and merge beautifully into one another.

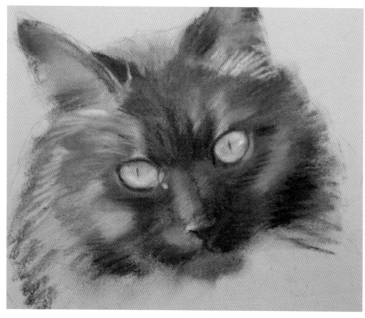

Step 3

Here, you can clearly see how the three steps overlap each other. The body is still sketched out in rough lines using pastel pencil. The neck ruff is established in grey, light yellow and ochre and then smudged with my finger. For the areas that are white in the subsequent stages, I first of all shade them with ochre as a background. This makes the white a warmer white. In the coat demonstration (see page 130) you can see how I create layer upon layer of depth in the long white coat. In order to soften the transitions between dark and light colours in the fur, I often use an extra colour between them. An example of this is the ochre that can be seen between the chest and the neck ruff. I first create the ear tufts in grey and then add the brightest white later as a highlight, with white pastels.

Eye demonstration

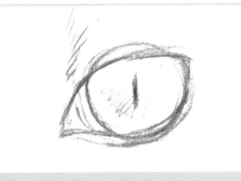

In order to leave space for an eye in a drawing, you have to realise that the round shape of the eyeball is only partially visible. The eyelids fall partly over it.

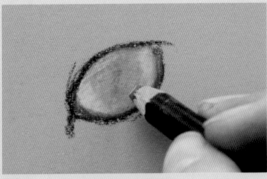

Step 1

I fill in the pencil drawing with ochre and the eyelids with dark brown.

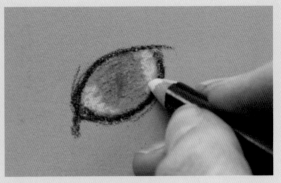

Step 2

Around the iris, I draw grass green and pale yellow on the outer sides. This suggests the curve of the eye.

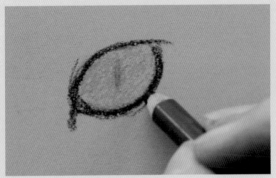

Step 3

After smudging it with my fingers, I add light grey and light blue.

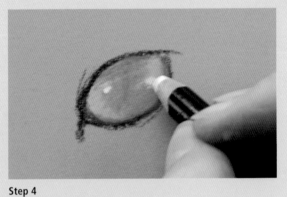

Step 4

I again smudge it with my fingers, and then add the sheen.

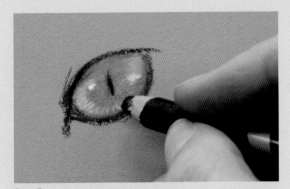

Step 5

I then add the pupil, paying attention to the direction. If I do not choose the correct angle, then the eye will not look correct. I add more details in yellow; I use the colour to draw thin lines in the iris.

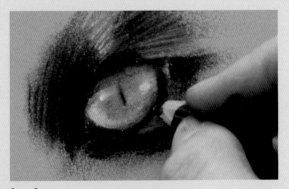

Step 6

Finally, I draw the fur around it using dark brown and black. I smudge the eyelids gently. Under the upper eyelid, I shade in the edge of the shadow in dark blue, so that there is a relaxed look. If I want to create a startled look, I omit this shadow.

Step 4

Cats' coats are much more colourful than you might initially think. In the coat of the body and the neck ruff of this Norwegian Forest Cat, for example, there are dozens of colours. You can enhance them at your own discretion. That is the freedom you have if you draw using pastel.

Here, I have tried for a realistic-looking end result, so I added subtle colours, ranging from dark red to ultramarine blue. To make the skull shape more three-dimensional, I used a light blue to draw between the ears, for the light is falling on the top of the cat's head. The warm ochres give a warm glow to the ears. The dark line along the eyes draws attention to the eyes.

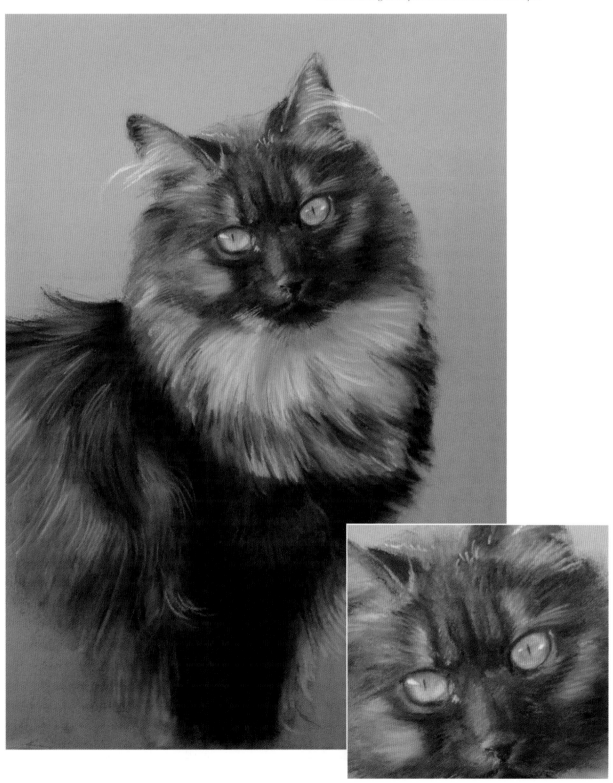

Coat demonstration

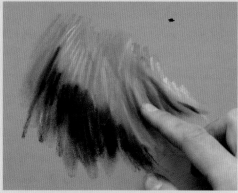

Step 1
With brown, black, ochre, mid- and light grey, I loosely sketch the coat.

Step 2
With my finger, I smudge the hairs in the direction of the fur. For the dark colours, I use a different finger.

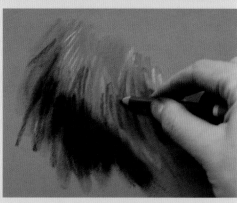

Step 3
With a medium grey, I add shadows from which I can pick out the lighter tufts.

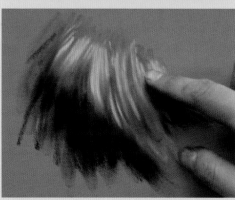

Step 4
Using white, I draw the lightest tufts, and then smudge it again with my fingers.

Step 5
Finally, I use a white chalk and I draw in the brightest white without smudging. That way, I am able to pick out previously drawn layers. Through the preceding layers that are present, you can create a three-dimensional coat.

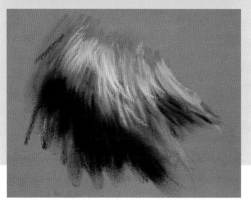

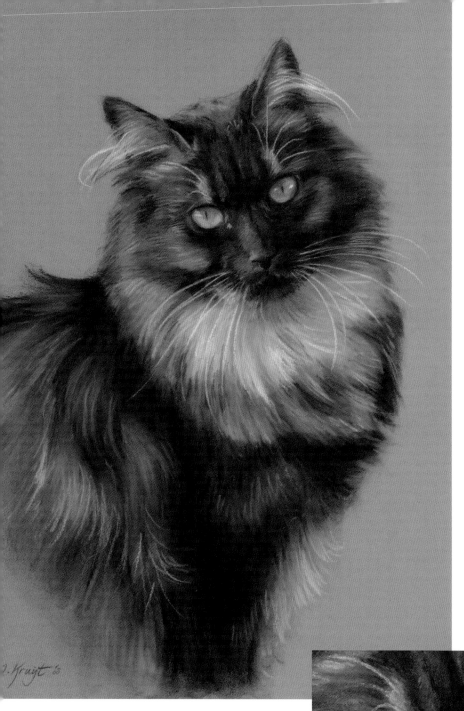

Step 5

The whiskers complete the portrait. They add lots of vibrancy and playfulness to the whole thing. All cats have a number of tufts above their eyes on either side, and some have single tufts on their cheeks, too. I draw the whiskers and ears in a careful arc using pastel pencil and pastels. What gives a portrait that wonderful quality of depth and dimension, is the soft outer edge of the coat (contours). If you compare this image with the previous step, you will see that the edge of the coat is softened with grey. On the top of the head, the colour of the light is almost entirely the same colour as the paper.

I have not added a background because, in this instance, it would be a distraction. The focus is on the eyes of the cat, and its beautiful diva-like attitude and neck ruff.

'Norwegian Forest Cat', 30 x 40cm
(11¾ x 15¾in), pastel on Colourfix

Close–up step 5

Here you can see the chosen variety of colours and how the light edge hairs along the lips have been drawn. This kind of detail adds sophistication to a portrait, even if further techniques are followed in a relatively loose fashion. I often soften the start of the whiskers with a grey pastel. The shadow just below the eyelids adds more depth to the eyes and gives a glassy effect. There is a light tip to the nose, causing it to come to the fore. Without this light, the nose looks flat, like that of a Persian cat.

RABBIT IN OILS

A rabbit's fur is mixed. If you take a look at some loose fur, you'll see that the colour varies from root to tip, just like a tabby cat or sheepdog. In this demonstration I will show you how you can paint this diversity in oil, with the help of old, discarded brushes.

The inspiration behind this painting was a meeting with a small, wild rabbit. I placed him in a quiet setting so I could enhance the symbolism of finding a four-leaf clover in a brackish environment.

Materials

H pencil
Oil paints (see colour palette on page 17)
Linen canvas 60 x 30cm (23½ x 11¾in)
Linseed oil
Synthetic brushes: size 6 flat, size 8 flat, size 1 round
A variety of old hog hair brushes: flats and rounds

Step 1

I've chosen a portrait-linen canvas, which has less texture than the ready-made linen canvas types. I stretched this myself over stretcher bars. First, I made a composition sketch in my sketchbook. Then I set the rabbit down on to the canvas using an H pencil. I made a detailed drawing so that the proportions were correct.

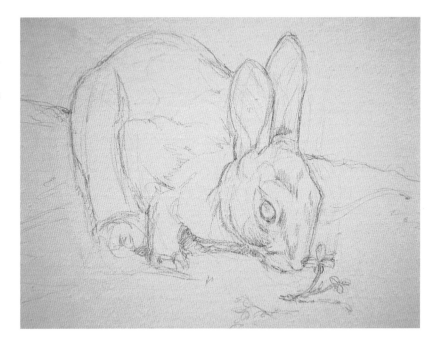

Step 2

This oil technique is different from that used in the Borzoi demonstration. Instead of wet-in-wet with opaque paint, I worked here using a wet-in-wet technique into a semi-transparent medium layer with a transparent paint. First, I fix the drawing with a transparent layer of ochre. I then paint the head with a size 6 flat synthetic brush in burnt umber. This means that I have already laid down the direction of the fur. This layer forms the wet basis for the next steps.

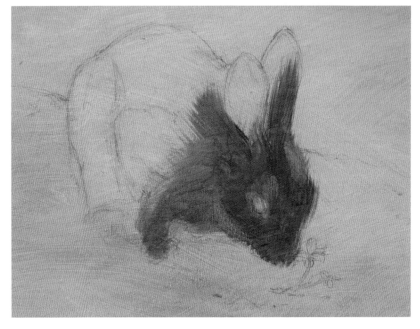

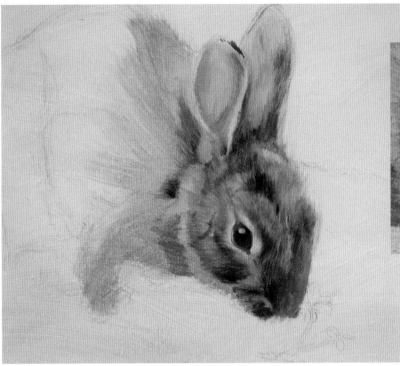

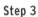

Step 3

With an old, spindly hog hair brush, I paint all over the coat in an undiluted Vandyke brown colour. I do not press too hard: I use only the bristle tips of the brushes. The medium picks up the pure paint. By using the brush like a blade, you can add instant detail to the fur. I repeat the process using sienna and white.

The close-up clearly demonstrates the three colours. The paint is still transparent, so the pencil lines and underlying ochre are still visible. I loosely add the eyes as a layer with a standard size 1 round brush, using burnt umber and Vandyke brown for the rims of the eyes. I chose to do the sheen last of all, with a light blue and white.

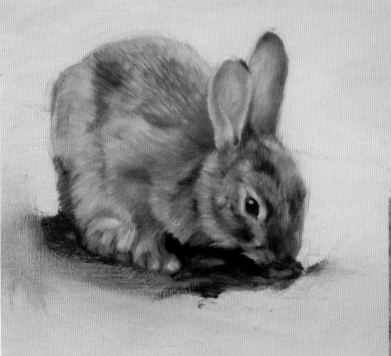

Step 4

Then I repeat the same process with the three colours across the entire body. I do not use black, because I want the colours to be as bright as possible. The dark hairs are a mixture of ultramarine blue and Vandyke brown. I sometimes smudge the transitions between the hairs with a clean, dry, flat brush, making them seem softer. I save the painting of the brightest light sections for later.

Ears

Step 1
First, I apply a brown transparent base, diluted with medium.

Step 2
Wet-in-wet, I paint the pink and the shadows with a broken brush.

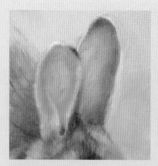

Step 3
I then paint the hair in there and smudge it with a dry brush.

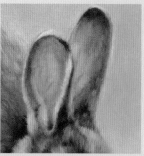

Step 4
After it has dried, I paint in the last details in a new layer of medium.

Step 5

I paint the environment in loosely rather than in detail, using a size 8, soft, flat synthetic brush. To suggest depth, I add some blue into the background. The warm brown visually moves further forward against the cool blue. I now leave the painting to dry for a number of days.

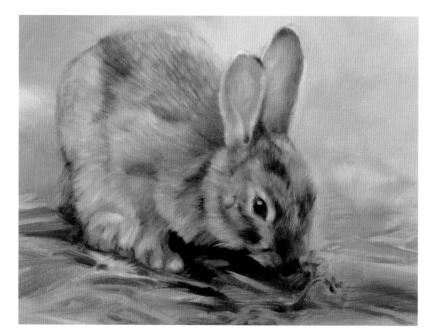

Step 6

Now that the painting is dry, I first add a very thin layer of bleached linseed oil (medium) over the entire canvas. This should not be too thick, as there is newly-applied paint. I then work on the texture of the coat and the details, again using an old, round brush. I then work on the deep shadows and highlights. You can repeat this stage more often, just allow the painting to dry for a few days in between.

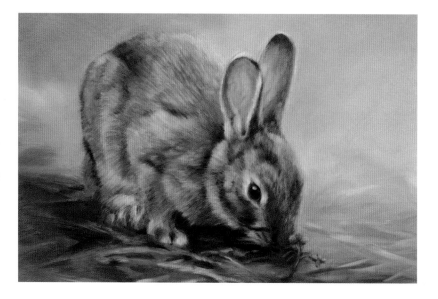

Now I work more on the contrast, looking at areas of fur in the shadows, along with the lightest sections of the fur. I no longer work with old brushes, but with the tip of a thin brush. This step takes no more than an hour. In this image, the many layers of fur are clearly visible. The light still appears to shine through the background.

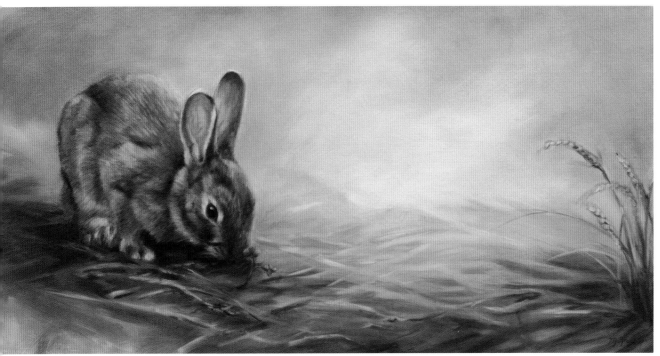

'Rabbit', 60 x 30cm (23½ x 11¾in), oil on canvas

Wet–in–wet glazing

Here, you can see the difference between using a brush to smudge paint on a dry surface, and then using the same brush, over a thin layer of linseed oil. Wet-in-wet suggests fluidity of the fur. This technique, involving three or four layers over each other, guarantees beautiful fur.

Brushes

Old brushes are great for painting coats.
From left to right: new flat hog hair brush, used flat hog hair brush, worn down round hog hair brush

DOG IN OILS

In this demonstration, I want to show the variation in the coat colour of a black and white dog, because the coat does not just consist of different shades of black and white. Black fur often has a brown undertone to it, which you can only see if the animal is in the sun. A white coat rarely appears pure white: a warm light gives an orange glow to it, while outdoor light gives a cool blue sheen from above. A white coat is mainly made up of shadows and colours that are determined by how warm the light colour is.

Materials

HB pencil
Oil paints (see colour palette on page 17)
Canvas panel 30 x 40cm (11¾ x 15¾in)
Bleached linseed oil
Synthetic brushes: size 1 round, size 3 round, size 10 fan brush
Hog hair brushes: size 6 flat, size 10 flat and size 4 round

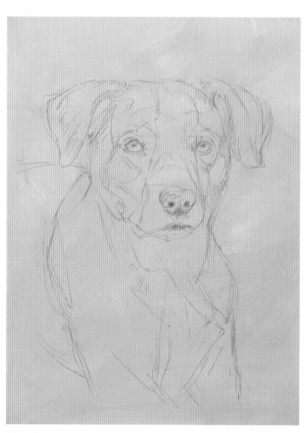

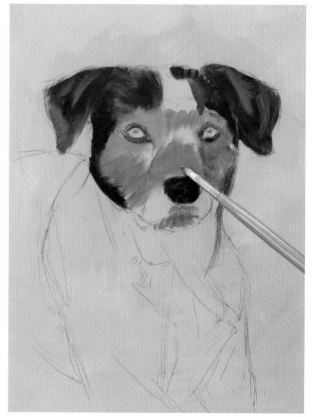

Step 1

I chose to use a panel with gesso for this painting. With an HB pencil, I sketch the round shape of the head so that it was positioned correctly, with not too much background and the head just above the centre. I then add detail to the eyes, ears and chest and check the proportions. I fix the drawing with a diluted layer of white acrylic paint, mixed with a touch of sienna.

Step 2

This portrait uses a combination of the oil techniques used in the Borzoi and the rabbit projects. First, I paint the midtones with a size 6 flat brush. With just a loose touch, I add a covering layer to parts of the portrait, as I did with the Borzoi. I wanted to develop the muzzle and eyes in detail in transparent layers. For the head, I use Vandyke brown, and for the muzzle, a mixture of white, ultramarine blue and a little Vandyke brown.

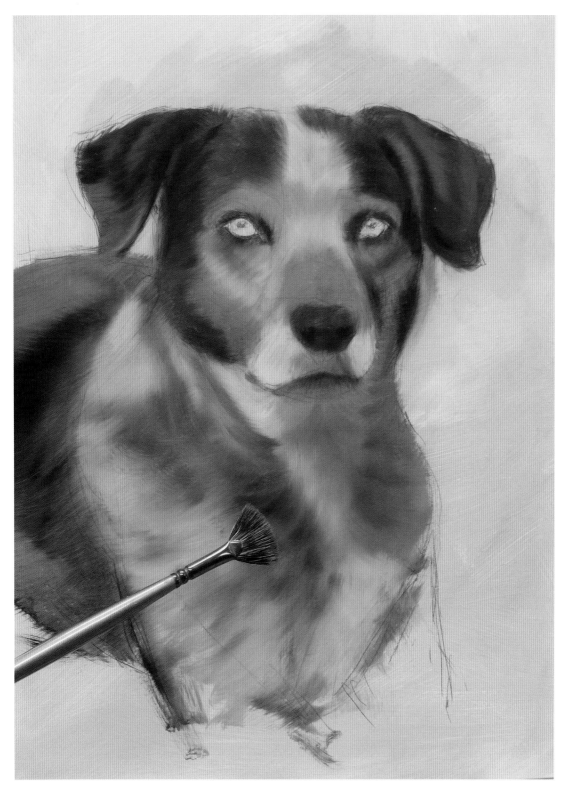

Step 3

In order to let the paint flow over the panel sufficiently, you can apply a very thin layer of medium before you start. Once all of the midtones have been painted, I blend all of the colours into each other using a fan brush. For this, I pay attention to the direction of the fur. In between, I clean the brush, otherwise the light colours could bleed into the dark ones.

Eyes

I paint the eyes in two layers, in between which the paint can dry. In these four pictures, you can see the continuous process.

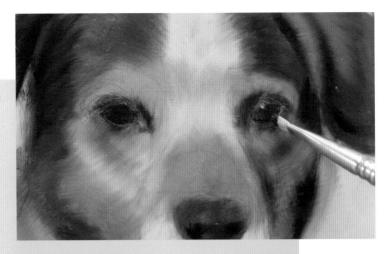

Step 1

Using sienna, I paint in the eyes, paying attention to the radiant form of the iris. The pencil drawing shimmers through it.

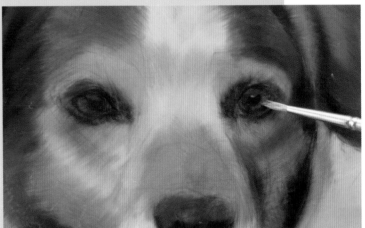

Step 2

I add some light streaks to the iris using a mixture of yellow ochre and white. With two dashes of grey blue, I specify where the highlights are.

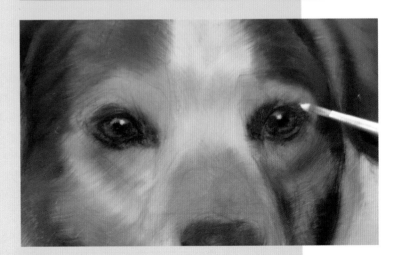

Step 3

With a mixture of Vandyke brown and ultramarine blue I paint in the pupils, then using white, I highlight the points in the eyes.

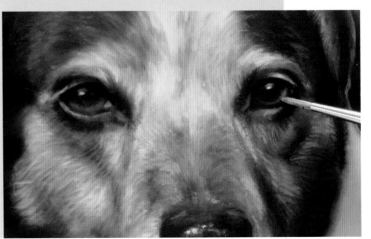

Step 4

After the painting is dry, I paint in the rims of the eyes in transparent layers, as well as the light that falls at the bottom of the eye. The shadow under the upper eyelid makes his gaze look peaceful.

Step 4

I then paint the background with a size 10 fan brush. I first choose a mid-tone of sienna with white, which I smudge evenly using a fan brush. I smudge the transition of the edges of the fur in the background, in order to soften them. Next, I add a light touch of wet-in-wet shading in white behind the dog.

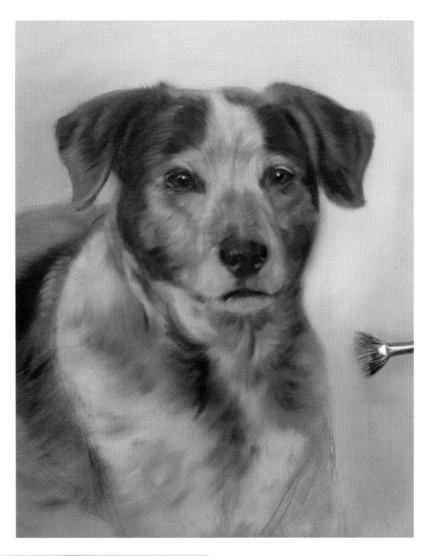

Step 5

I then left the painting to dry for a couple of days. After that, I applied a thin layer of linseed oil over the entire painting before I progressed to the hairs. I start with the light grey colours, and finish with the whitest colours. Mid-grey and light grey tones are used on the ears. On the right of the picture, on the cheek, you can clearly see the effect of the three grey tones built up on each other.

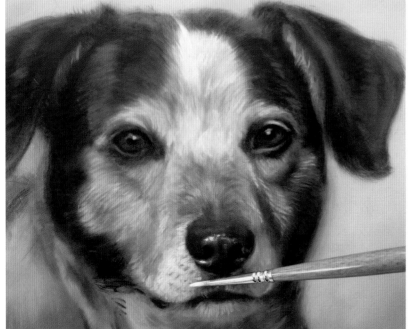

Step 6

This stage adds life to the portrait: the refinement in the sharp hairs on the muzzle and the chest hair. Too many details can make a painting look stiff, so feathering can work to soften them and make them less prominent.

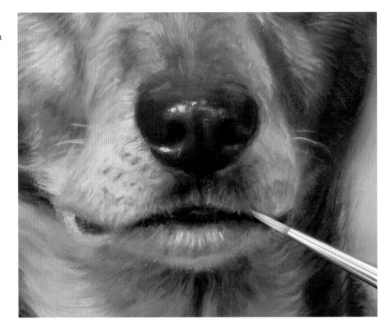

Step 7

I check whether the ratio between the details and looser, soft parts is accurate, so that it gives a three-dimensional suggestion that the dog will come out of the painting. After drying it a second time, I glaze the darker parts of the coat with umber, so the portrait comes over as warmer.

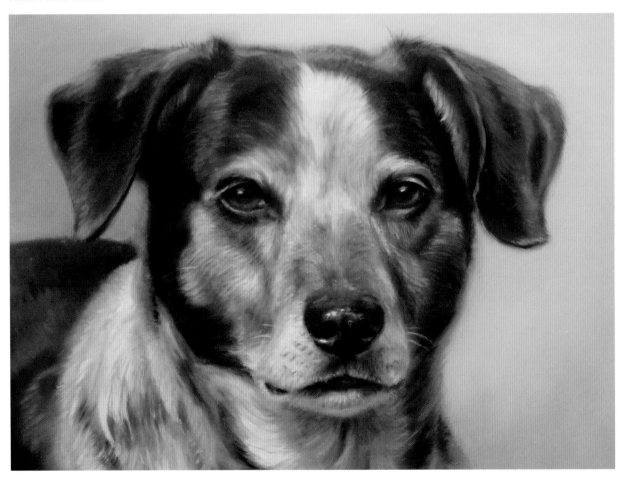

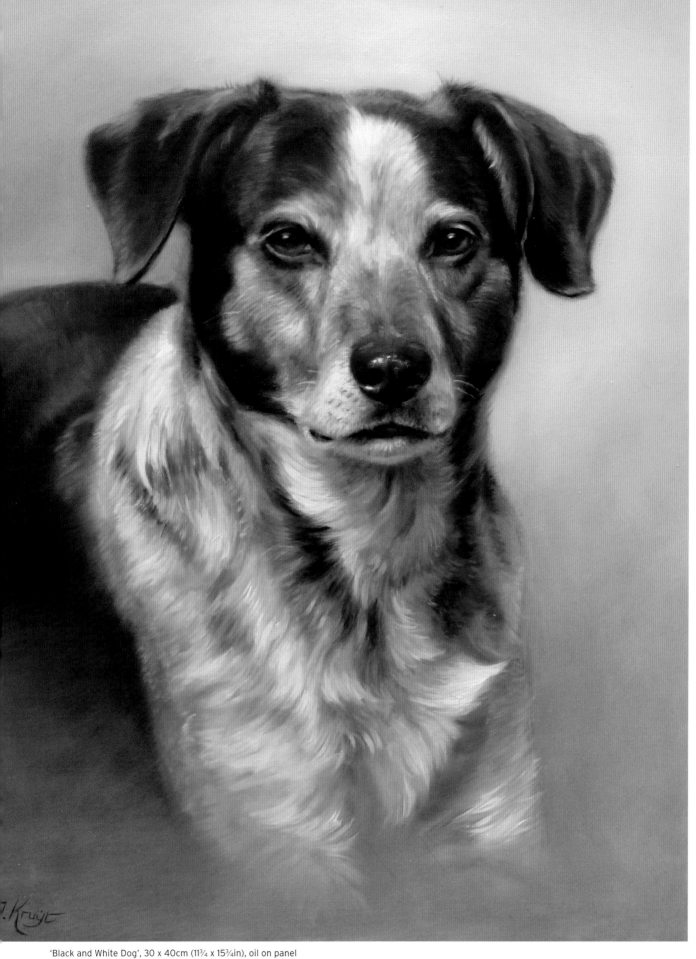

'Black and White Dog', 30 x 40cm (11¾ x 15¾in), oil on panel

Biography

Marjolein Kruijt was born and raised in Mijdrecht and has been drawing for as long as she can remember. After training as an art teacher (Amsterdam) and studying at the Royal Academy of Art (The Hague), she has given in to her passion completely and she now works full time as an artist.

Her passion for nature and animals is reflected in her wildlife and landscape paintings. She also accepts commissions to paint portraits of animals/pets. Her realistic painting style is characteristic of her work. As a tribute to the beauty of her subjects, she strives for depth in her work, capturing life and inspiration. Sometimes she portrays animals with a touch of humour, or simply in all their vulnerability.

Marjolein's paintings have been published in *International Artist* magazine. In addition, she is known for her instructive articles in the magazine, *Atelier*. Her animal portraits and wildlife paintings can be found in collections worldwide. Each year, she also brings out the Marjolein Kruijt Nature Calendar, filled with more than fifty paintings.

More of Marjolein's work can be found on her website: www.marjoleinkruijt.nl